W9-AAC-830

16th DASM    16 JAN 99

# THE RENAISSANCE

## MASTERPIECES OF ART AND ARCHITECTURE

SUSAN WRIGHT

SMITHMARK

Copyright © 1997 by Todtri Productions Limited.
All rights reserved.
No part of this publication may be reproduced, stored in a
retrieval system or transmitted in any form by any means
electronic, mechanical, photocopying or otherwise, without
first obtaining written permission of the copyright owner.

This edition published in 1997 by
SMITHMARK Publishers,
a division of U.S. Media Holdings, Inc.,
16 East 32nd Street, New York, NY 10016.

SMITHMARK books are available for bulk
purchase for sales promotion and premium use.
For details write or call the manager of special sales,
SMITHMARK Publishers,
16 East 32nd Street, New York, NY 10016;
(212) 532-6600.

This book was designed and produced by
Todtri Productions Limited
P.O. Box 572, New York, NY 10116-0572
FAX: (212) 279-1241

*Printed and bound in Singapore*

Library of Congress Catalog Card Number 97-066044

ISBN 0-7651-9224-1

*Author:* Susan Wright

*Publisher:* Robert M. Tod
*Editorial Director:* Elizabeth Loonan
*Book Designer:* Mark Weinberg
*Senior Editor:* Cynthia Sternau
*Project Editor:* Ann Kirby
*Photo Editor:* Edward Douglas
*Picture Reseachers:* Heather Weigel, Laura Wyss
*Production Coordinator:* Jay Weiser
*Desktop Associate:* Paul Kachur
*Typesetting:* Command-O

PICTURE CREDITS

Accademia, Venice—Art Resource, New York 82, 84, 109

Art Resource, New York 5, 10, 17, 18, 24–25, 26, 27, 28, 29, 30, 31, 34–35, 36–37,
40–41, 44, 45, 46, 51, 52–53, 58 (top & bottom), 72–73, 76, 77, 78–79, 80, 81, 87,
88–89, 91, 96, 97, 99, 100–101, 106, 112, 119, 120–121, 123, 127

Bargello, Florence—Art Resource, New York 32, 33
*Images of World Architecture* by Jim Harter (copyright-free engravings, published by
Bonanza Books, New York, 1990) 14, 23. 90, 102, 118, 122, 125

Biblioteca Nazionale, Florence—Art Resource, New York 49

Borghese Gallery, Rome—Art Resource, New York 116–117

Brera Gallery, Milan—Art Resource, New York 86

British Museum, London—Art Resource, New York 74

Galleria delle Carte Geografiche, Vatican—Art Resource, New York 75

Gemaldegalerie, Dresden—Art Resource, New York 92

Graphische Sammlung Albertina, Vienna—Art Resource, New York 67

Kunsthistoriches Museum, Vienna—Art Resource, New York 19, 55, 56–57,
103, 108, 126

Louvre, Paris—Art Resource, New York 13, 38, 71, 83, 85, 95

Museum of Fine Arts, Antwerp—Art Resource, New York 70

Musée Conde, Chantilly—Art Resource, New York 48

Musée Unterlinden, Colmar—Art Resource, New York 61, 63

Museo di Firenze com'era, Florence—Art Resource, New York 20–21

Museum of Fine Arts, Budapest—Art Resource, New York 8–9

National Gallery, London—Art Resource, New York 54, 59

Palazzo Vecchio, Florence—Art Resource, New York 107

Phillips University, Marburg—Art Resource, New York 65, 66

Picture Perfect, USA 15, 22

Pinakothek, Munich—Art Resource, New York 64

Pitti Gallery, Florence—Art Resource, New York 43

Prado, Madrid—Art Resource, New York 50, 60, 115

SEF—Art Resource, New York 124

State Art Gallery, Dresden—Art Resource, New York 111

Uffizi Gallery, Florence—Art Resource, New York 6, 35 (bottom), 39, 42, 47,
68–69, 93, 94, 98, 110, 113, 114

Ufficio Direzione Palazzo Ducale, Venice—Art Resource, New York 104–105

Vatican Museum, Rome—Art Resource, New York 11

# Contents

# Introduction

The Renaissance was a period of cultural growth that began in Italy and spread throughout northern Europe, lasting from approximately 1400 to 1600. Traditionally the Renaissance is considered to be the beginning of the modern age; the thousand years between antiquity and the Renaissance is thus popularly known as the middle ages, or the medieval period.

The Italian word for Renaissance ("*rinascimento*") means "revival." The scholars and artists of the Renaissance believed they were participating in a rebirth of the ideals and values of the classical Greek, Hellenistic, and Roman eras (lasting from 500 B.C. to A.D. 330, when Constantine moved the capital of the Roman Empire to the Greek city of Byzantium).

Renaissance scholars admired the philosophy, art, and literature of the ancient Greeks and Romans, rejecting the values and stylized conventions of medieval Gothic and Byzantine forms. Instead of relying on decorative lines and color to glorify scriptural stories and icons, the artists of the Renaissance rediscovered the importance of individual will and the necessity of observing nature in order to express drama and emotion in human terms.

As artists mastered the knowledge of antiquity, they began to improve on the surviving artifacts, taking full responsibility for their creations. Renaissance humanism was nurtured by political and economic changes such as the growth of urban society, the interconnectedness of trading nations, and the printing press, which gave the average man access to works of philosophy, literature, and art.

For the purposes of this book, the Renaissance has been divided into four periods: the Early Renaissance (roughly 1400–1495), the Northern Renaissance (1400–1525), the Italian High Renaissance (1495–1520), and Mannerism (1520–1600). Each of these periods is distinct in style and content, following the development of humanism in Western Europe.

**The Loggia of the Farnese Palace**

*RAPHAEL and assistants, 1518–19; ceiling fresco. Farnese Palace, Rome.*

Interior decoration changed during the Renaissance through the influence of newly discovered Roman wall decorations. Raphael was inspired by the rooms of Nero's "Golden House," which had been recently excavated from the grottoes.

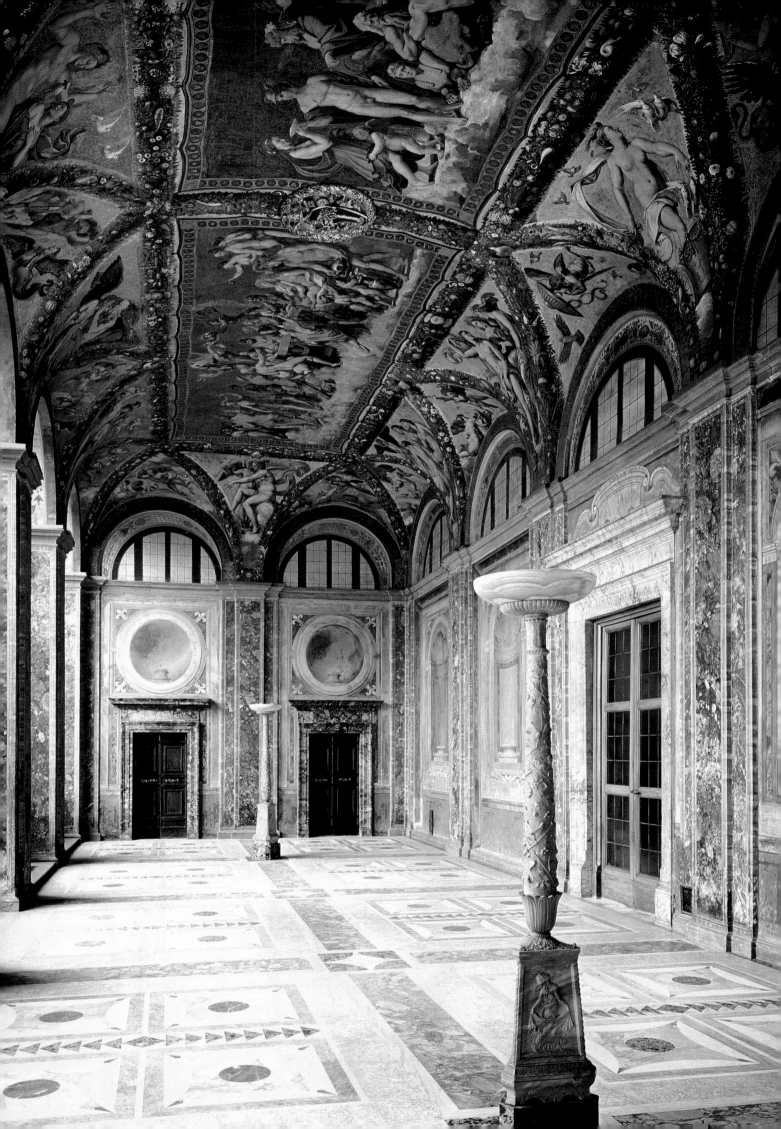

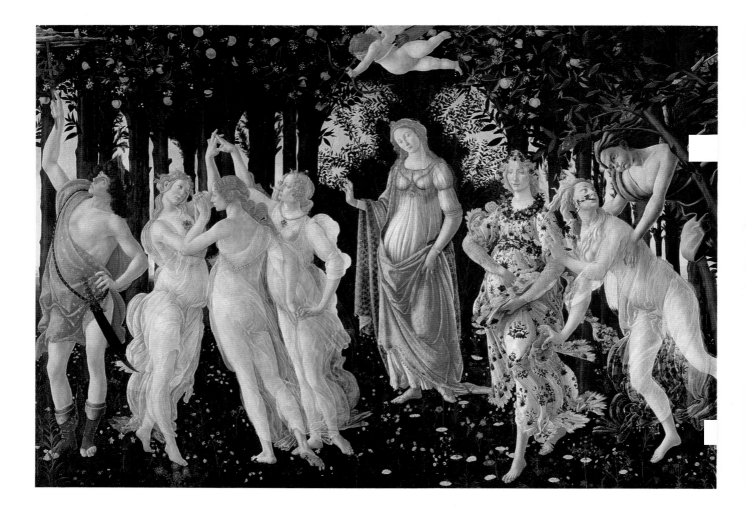

## Primavera

*SANDRO BOTTICELLI, c. 1478; tempera on panel;*
*6 ft. 8 in. x 10 ft. 4 in. (203.2 x 314.9 cm). Uffizi Gallery, Florence.*
In this painting, the main figure of Flora is attended by
Botticelli's version of the three Graces. The three Graces
can also be seen in Francesco del Cossa's *The Triumph*
*of Venus* (1470), and on the reverse side of Niccolo
Fiorentino's medal of Giovanna Tornabuoni (1486).

# AN AGE OF CHANGE

Many modern scholars mark the fall of Constantinople in 1453 as the end of the middle ages. Constantinople had long nurtured a culture of Christianity and learning but when the Turks overran the city, refugees were driven west into Europe. Among these refugees were Greek scholars whose goal was to save their precious classical manuscripts. These Greek scholars survived by teaching classical theories to European scholars, and they passed along their knowledge of the Greek language, enabling Europeans to translate the ancient texts for themselves.

## Ancient Manuscripts

Books were treasured rarities in the early fifteenth century. Monastic schools only allowed their manuscripts to be read or copied within the monks' scriptoria. Privately endowed scholars had to travel to centers of learning and laboriously copy each text for their own libraries. Students were taught through lectures rather than individual study, establishing the foundations of the current University system.

Even before the fall of Constantinople, a classical revival was begun by the return of the papacy to Rome after a string of French popes underwent an extended residence in Avignon. From 1378 to 1417, during the Great Schism within the Roman Catholic Church, a series of important church councils were held to settle the rival claims of popes and various factions. These councils drew men of learning from all parts of Europe and they provided valuable opportunities for scholars to examine the collections of manuscripts in monastic libraries throughout Italy and southern France.

Cosimo de' Medici participated in the Council of Constance (1414–18)—which ended the schism—as the representative of the Medici bank, in charge of managing the Council's finances. Soon thereafter Cosimo began to manage all of the papacy's investments, and branches of the Medici bank were established in every large city in Europe.

It was during the years of the Council of Constance that Cosimo began a lifelong devotion to searching for classical books. Cosimo was such an avid collector of manuscripts that he once ordered two hundred volumes at the same time, despite the fact that it was extremely expensive and laborious to hand-copy the texts. It took two years for forty-five scribes to complete the task, and all costs were paid by the Medici bank. Cosimo de' Medici's humanist library in Florence was one of the largest private collections during the fifteenth century, and in the spirit of civic munificence it was open to the public.

Another Florentine scholar, Niccolo Niccoli, gathered a vast collection of ancient art objects and a library of classical texts (many had been copied by Niccoli himself). Scholars from across Europe visited Italy to see Niccoli's collection, and upon his death the

*FOLLOWING PAGE:*

**The Crucifixion**

*detail; JAN VAN EYCK, c. 1420–25; canvas transferred from panel;*
*22¼ x 7¾ in. (56.5 x 19.6 cm). Museum of Fine Arts, Budapest.*
The development of landscape painting as an independent
genre was first seen during the Renaissance—a result of man's
mortal, more earthly focus. Here, even the temple is crowded
by the city of Jerusalem and its protective, turreted walls.

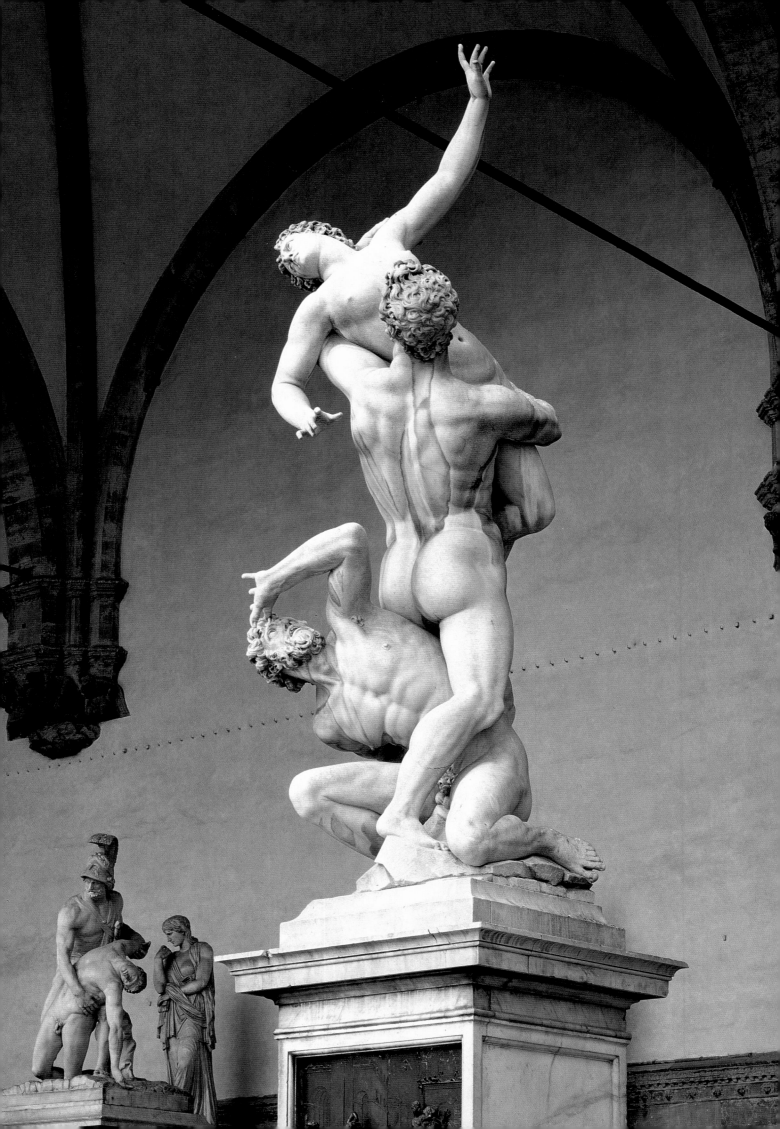

manuscripts were given to the library of the Dominican house of S. Marco. Cosimo de' Medici paid much of Niccoli's debt to insure that the priceless manuscripts remained in Florence rather than being sold off and scattered across distant lands. And by 1475, Nicholas V had assembled in Rome the core of the Vatican Library, consisting of over 1,100 texts with nearly one third in Greek and the rest recent Latin translations.

These ancient works offered a great deal of theoretical information to European artists. Marcus Vitruvius Pollio's manuscript *De architectura* (first century B.C.) was discovered in 1415, and provided valuable descriptions of Greek and Hellenistic architecture, including the classical orders, city planning, and wall painting.

Medieval scholars knew about Vitruvius from Pliny the Elder, who cited Vitruvius as a source in *Natural History*, an encyclopedia of Greek science and history (*Historia naturalis*, A.D. 77). Pliny had compiled material by earlier authors into thirty-seven books which examined "the nature of things, that is, life." Along with books on astronomy, zoology, botany, and geography, Pliny examined the political history of the Greek city-states and provided biographical information on notable Greek scholars and artists. He even recorded works by the ancient Greek artists Phidias and Apelles, and

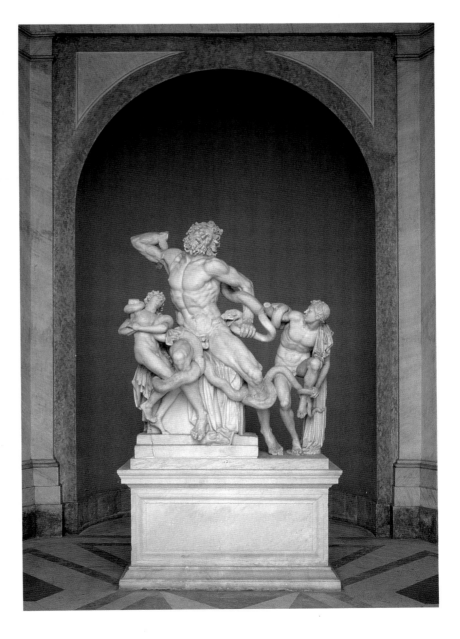

**The Rape of the Sabine Woman**

*GIOVANNI BOLOGNA, c. 1580; marble.*

*Loggia dei Lanzi, Florence.*

Bologna directly copied figures from the illustrious antique sculpture *The Laocoön Group* in his crouching old man and in the way the woman twists as she reaches one arm into the sky. Typical of the Renaissance, Bologna improves upon the ancient composition, interlocking the figures on an axis to create a spiraling movement rather than using the coils of the snakes to link the figures.

**The Laocoön Group**

*Late 2nd century B.C.; marble.*

*Vatican Museum, Rome.*

According to Roman scholar Pliny the Elder, this sculpture was the finest in antiquity. Stylistically, it represents the late Roman tendency to replace the calm, stable, harmonious world of classicism with movement, tension, and emotion.

included a full description of the renowned sculpture *Laocoön*.

Renaissance artists were inspired by Pliny's recountings. In particular, Leon Battista Alberti encouraged the idea of the artist as creator rather than mere technician. Alberti wrote a series of Latin works on subjects ranging from law and family to art and architecture. In 1436 *Della pittura* was circulated in manuscript form, and in 1452 he produced a counterpart to Vitruvius's book called *De re aedificatoria libri X* (*Ten Books on Architecture*).

As ancient forms of art and humanist learning were disseminated throughout Europe, contemporary art was created imitating these patterns. This included the use of forms found in pagan temples and triumphal arches that were often incorporated into designs for church façades and personal residences.

During the middle ages, art had served the needs of the Church. This tradition was continued during the Renaissance by legendary papal patrons and wealthy ecclesiastics who were associated with the papal court. In addition to hiring artists to create new structures and works of art, the popes encouraged the study of antiquity. In 1510, Julius II hired Bramante to build the Belvedere Courtyard in the Vatican so that artists could sketch the few pieces of ancient sculpture that had survived: the Apollo Belvedere, an ancient Roman copy of a fourth century B.C. Greek bronze, and the *Laocoön*, which was discovered in a Roman vineyard in 1506.

Secular rulers too required opulence and splendor to accentuate their position in Renaissance society, so they hired the services of the best artists and architects. In much the same way that the cities of Brussels, Antwerp, Prague, and Madrid owe their prestige to the power of the Habsburgs, the Medici were the patrons of Florence. In France, King Francis I had a collection of casts of ancient statues at Fontainebleau, and Albrecht V's Antiquarium in Munich was the home of northern Europe's first comprehensive collection of ancient statues and portrait busts.

Artists from Alberti to Holbein were called on by rulers to decorate elaborate works for state entries into foreign cities and costly pageants to celebrate weddings or festivals. Many of the ceremonial statues and triumphal arches completed during the Renaissance were never meant to stand. Henry VIII was so anxious to impress King Francis I that he employed thousands of people to construct an enormous, temporary palace for the meeting at the Field of Cloth of Gold (1520) near Calais.

## Humanism

The Renaissance was an age of transition from the theological preoccupations of medieval feudalism to an age of secular materialism. The dogma of religion was challenged by the clergy itself when, in the thirteenth century, St. Francis of Assisi founded the influential Franciscan order. Franciscan friars spread throughout Europe teaching a version of Christianity which emphasized a reverence for the beauty of the world and the inherent goodness of living a simple, natural life.

Petrarch, the fourteenth-century Italian poet and scholar, was the first great humanist who formulated the Renaissance concept of individualism. Petrarch's

**The Three Graces**

*c. 100 B.C.; marble. The Louvre, Paris.*

This Hellenistic sculpture was well known during the Early Renaissance, a period when artists blatantly copied classical mythologic subjects and even exact figural poses out of veneration for Greek and Roman ideals.

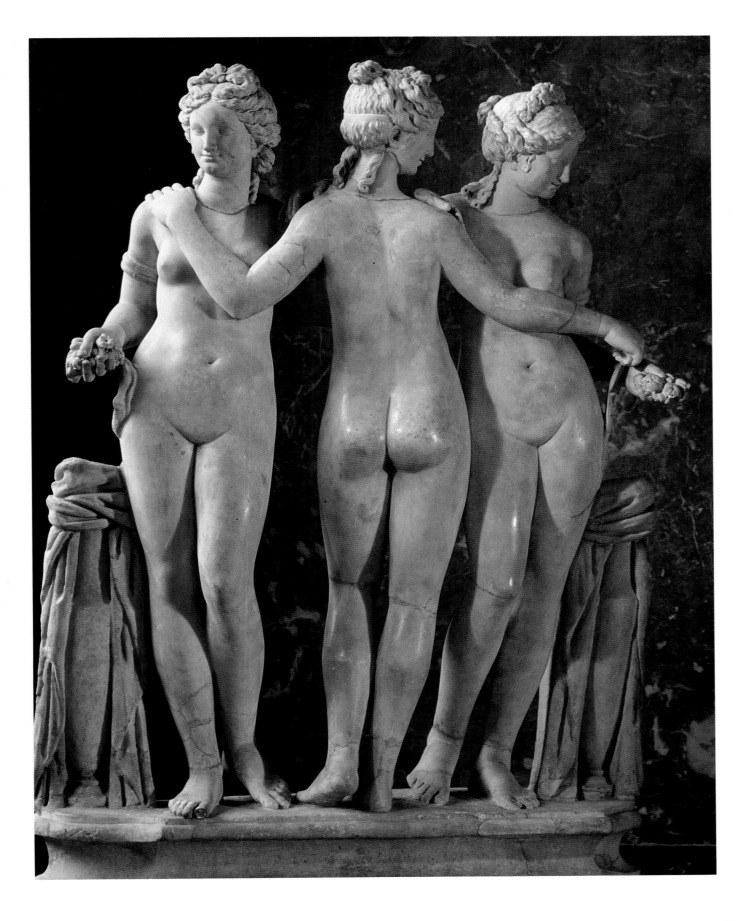

**St. Peter's**

*MICHELANGELO, 1546–64. Vatican, Rome.*
This early engraving shows a
cross-section of the dome and interior
of the celebrated St. Peter's basilica.

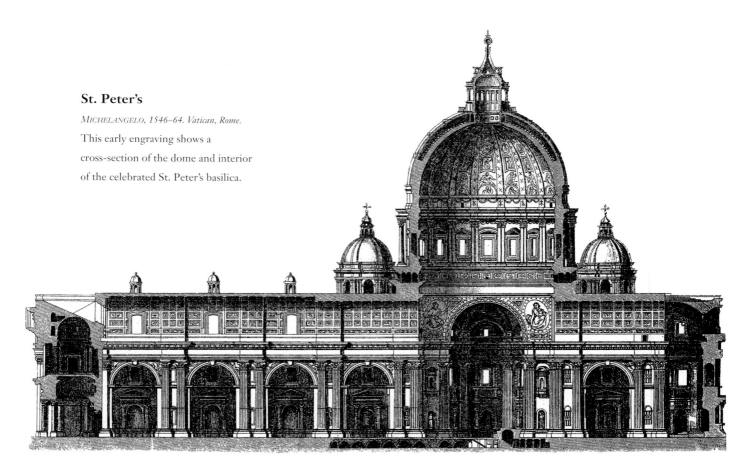

study of classical antiquity took him throughout Europe as he visited scholars and monastic libraries in his search for manuscripts. The Renaissance humanists, as opposed to the theologists, were interested in man and the qualities of human nature. Petrarch's texts and poems influenced art, literature, history, religious reformation, political systems, and even social manners.

During the Renaissance a money economy arose from the increase in intercontinental trade, establishing the basis for a temporal society. Merchants brought treasures of gold and foreign knowledge to the cities of Europe. Courts, which had long been the focus of government and administration, naturally became centers where scholars could go to find out more about the world.

Unlike the medieval universities that specialized in rhetoric, law, or medicine, a humanist education prepared the Renaissance man for life in the court and city. Humanist studies included lessons on poetry, music, philosophy, and history. Social dynamics and ethics were governed by rituals of manners and accomplishments (based on medieval notions of

chivalry) that had to be mastered as thoroughly as stanzas of classical poetry.

For the first time the individual gained unique importance. Class distinctions were shifting and those with merit or wealth could reach the top of the social hierarchy. A man could become great and powerful by possessing the divine gift of creativity. Philosophical debates over humanist values led to a belief that humans were intellectually capable of fine levels of discernment. Art became a mode of self-expression and discovery rather than a means of ornamentation. This can be seen in the rapid development of realistic portraiture as an independent genre.

The versatility of many Renaissance artists such as Alberti, Brunelleschi, Leonardo da Vinci, and Michelangelo led to innovation and experimentation not seen during the middle ages. Through patient, careful observation of the natural world, artists were able to develop mathematical systems (such as linear and atmospheric perspective), which was the origin of science.

The separation between science and the arts, philosophy and literature was not as seemingly clear-cut it is today. Mathematics and art went hand in hand, as did

science and art, thus enabling the artists of the Renaissance to express the ideals of their age through masterpieces of architecture and the human figure.

## Technology

The Renaissance was on the cusp of true science. It was a time when alchemy and astrology were pervasive, yet even these pseudo-sciences passed on benefits to modern man. Alchemy served to identify a vast number of chemicals, in spite of the fact that many alchemists did not fully understand how to effectively manipulate their materials. Astrology contributed a wealth of accurate observations of the heavens, even if the astrologers were not always able to make predictions through the movements of the stars.

Scholars combined the new methods of directly observing nature to find patterns and meaning, breaking things down in an attempt to analyze the inherent components. Renaissance advances in metallurgy, mechanics, navigation, and warfare changed the way humanity viewed the world at large.

In particular, the study of mathematics revolutionized art and architecture. Perspective and vanishing points were discovered, along with the technique of foreshortening which enabled artists to accurately represent three-dimensional objects, such as cubes and

### St. Peter's

*Michelangelo, 1546–64. Vatican, Rome.*

Michelangelo was appointed by Pope Paul III to complete the dome according to Bramante's plans. The original shape of the dome echoed the hemisphere of the Pantheon, but engineering needs necessitated a shell that was somewhat elongated.

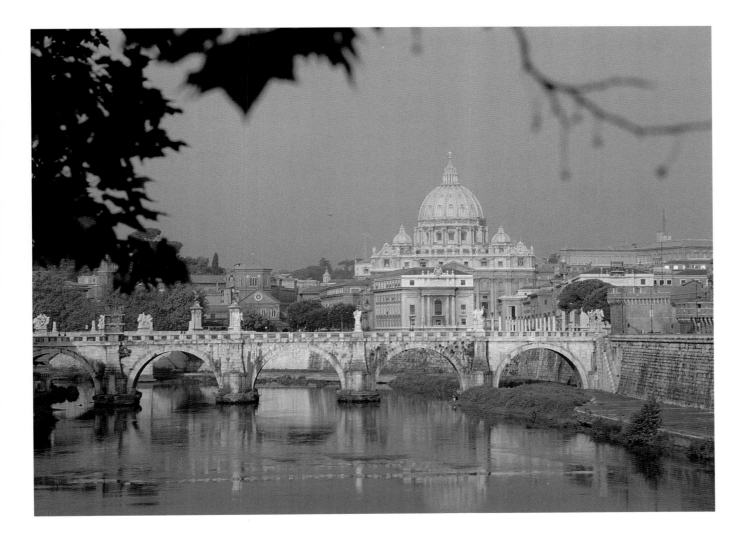

spheres, on flat surfaces. This meant an artist could realistically render anything at any angle, whether it was a person's head or the interior of a room.

Not only were visual perceptions changing, but people were experiencing a more complex view of time as a result of the increasingly commonplace existence of clocks. Urban life was enhanced by mechanical devices such as hydraulic systems that pumped water into fountains to provide a fresh and constant supply for city residents. Renaissance science also gave the world gunpowder, which transformed combat from hand-to-hand battle into long-distance killing with projectile weapons.

The compass and new kinds of ships were invented, promoting the discovery of the western continents and worldwide exploration. After 1492, scholars were priding themselves on the fact that the ancients had been ignorant of the so-called new world, proving that the Renaissance was not simply a revival but an improvement on ancient ways.

By 1520, Ferdinand Magellan's ship had completed its sail around the world, opening new trade routes and bringing with him an influx of eastern ideas. The need for accurate navigation led to the search for more precise ways to observe the sky, and this culminated in the invention of the refracting telescope by Galileo in the late sixteenth century. In 1543 Copernicus published his revolutionary theory declaring that the center of our solar system was the sun and not the earth, as Scripture had dictated.

The principal technological discovery of the Renaissance was the printing press. The printing press gave a wider public access to both classical and contemporary knowledge. Intellectual thought in Europe was changed by the explosive spread of scientific drawings on anatomy, botany, zoology, engineering, and mechanical processes, allowing scholars to build on each other's investigations rather than having to start from scratch every time.

Printing first developed in the Rhineland in the mid-fifteenth century, and the new invention quickly spread throughout Europe. Printing on parchment using wood blocks had been developed in the middle ages, but the arrival of paper from the East (along with imports of Chinese silk and porcelain) led to the development of cheap manufacturing methods.

The first book that Johann Gutenberg's press in Mainz printed was the Bible (1455). For centuries the Bible had been the most reproduced text by monastery scriptoria, and the earliest style of printing copied the style of manuscript texts, with the margins decorated by hand.

From the 1460s on, books were printed in every part of Europe. Religious books continued to be the most numerous, along with the Greek and Latin classics, as well as texts on practical and technological matters. Pliny's *Natural History* was first printed at this time.

Engravings were also made of ancient sculpture, architecture, and contemporary art. An engraving is a drawing incised on a metal plate. A print is made by inking the plate and pressing it against a sheet of paper. Many prints could be made from the same plate so this type of art was cheap and could be widely circulated. Italian prints had an important influence on northern painters, such as Albrecht Dürer, whose own prints still stand as masterpieces of the technique of engraving.

The printing press, which disseminated information faster than ever before, was also heralded as an achievement that proved the superiority of the Renaissance over antiquity. It is an ironic reversal that the ancient languages are now hardly printed except for University study, while reproductions of Renaissance masters can be meticulously produced, preserving these important works for generations to come.

### The Pantheon

*A.D. 118–125; marble. Rome.*

Marble of every color was used to decorate the walls and floor of this circular temple in geometrical patterns. Wall niches formerly held statues of pagan deities, but during the middle ages they were turned into saints' shrines.

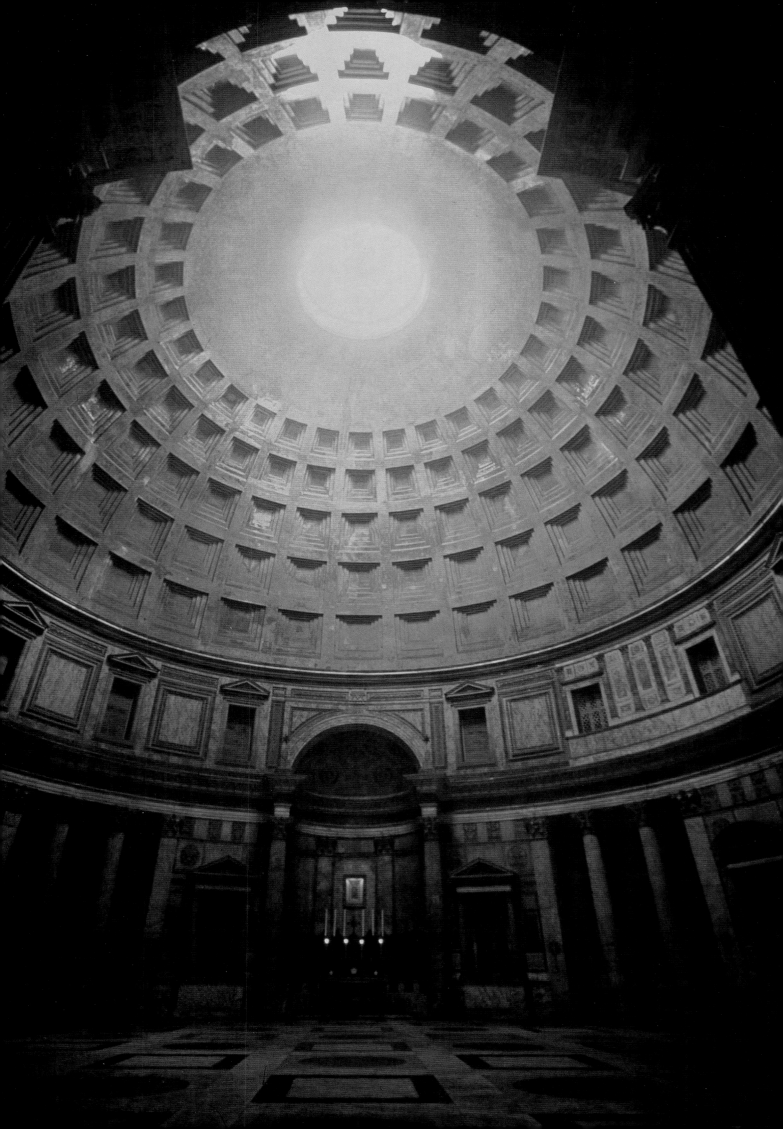

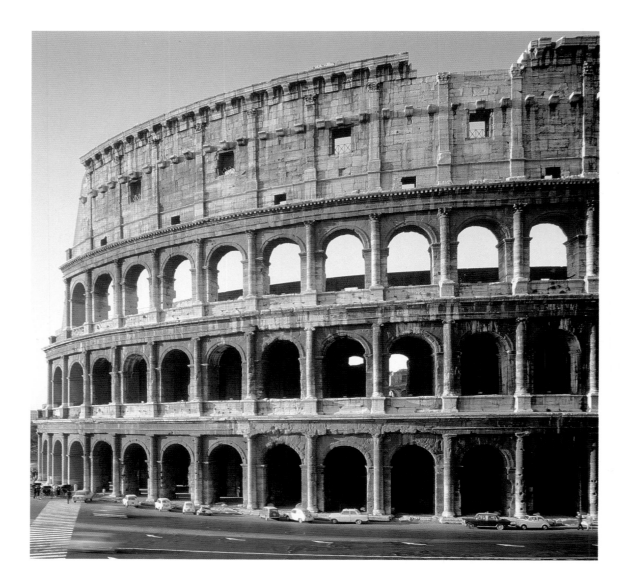

## The Colosseum

*A.D. 70–82; concrete. Rome.*

The Colosseum is the largest and best preserved Roman monument, proving that the Romans were masters of practical architecture. The terraced seating allowed fifty thousand spectators to view the games, while below ground level there was a maze of holding rooms for athletes, prisoners, and animals.

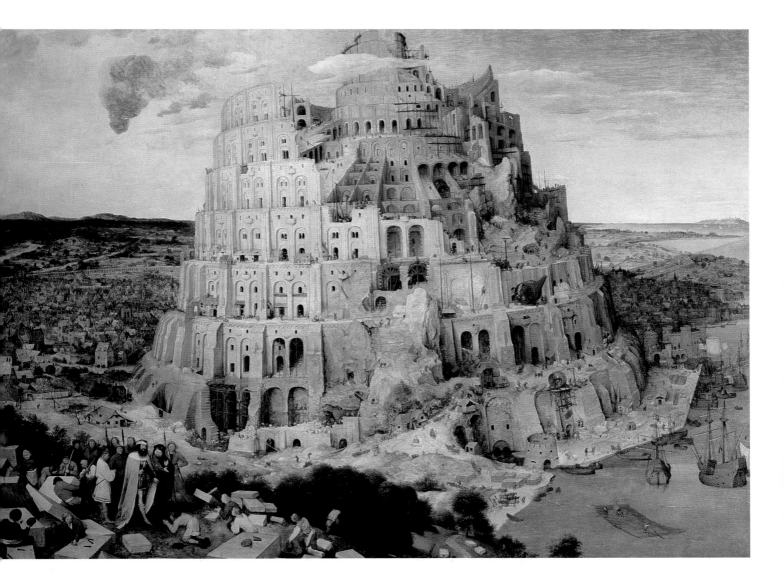

## The Tower of Babel

*PIETER BRUEGEL THE ELDER, 1563; oil on panel; Kunsthistorisches Museum, Vienna.*

Bruegel used the Colosseum as the model for his

*Tower of Babel*, theorizing that with such a sound architectural

basis, a tower could be built to reach into the clouds.

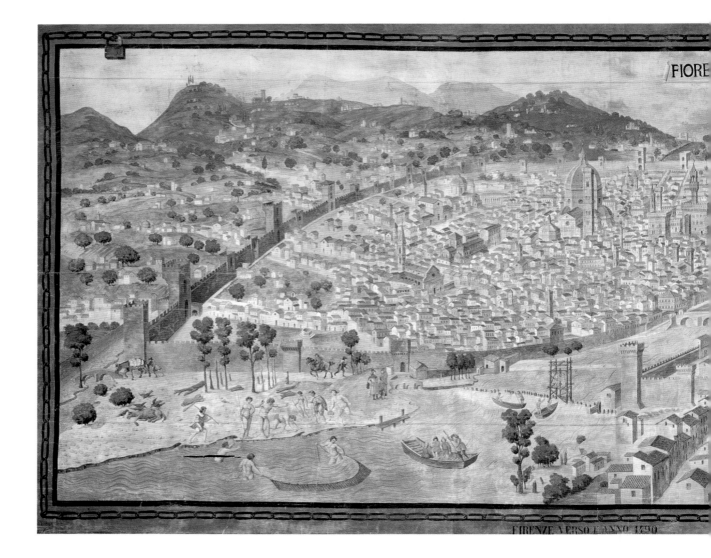

FIORE

FIRENZE VERSO L'ANNO 1790

# THE EARLY RENAISSANCE

**View of Florence**

*S. BUONSIGNORI, c. 1480; copy of the Carta della Catena.*

*Museo di Firenze com'era, Florence.*

This view of Florence depicts the walls of the city
protecting the bridges over the Arno. Florence
Cathedral is the dominant structure in the center of town.

During the Early Renaissance, Florence was the intellectual and artistic capital of Europe. The Italian peninsula was seeped in antiquity, with ruins of Roman structures and monuments testifying to the strength and grandeur of classical forms. Along with famous artists such as Leonardo da Vinci and Michelangelo, some of the more renowned citizens of Florence were Dante, Machiavelli, Galileo, and Amerigo Vespucci (who gave his name to the Western continents).

Florence was founded around the first century B.C. as a colony for Roman soldiers. The garrison was intended to protect the only practical north-south crossing of the Arno River. It is situated in the center of Italy, surrounded by the vineyards and orchards of the rolling hills of Tuscany.

By 1197 the Tuscan League controlled Florence, one of several powerful city-states in Italy that had established their territorial bounds by successful conquest of neighboring lands. Florence was economically the most prosperous city in Italy, with Florentine bankers the leading creditors not only for their own countrymen but all of Europe.

Though politically Florence was considered to be a democracy, the Medici family dominated the city. Giovanni de' Medici was elected chief arbiter in 1421, and his son Cosimo shrewdly utilized their banking empire to gain unofficial sovereignty over Florence. Eventually one of Cosimo's younger sons, Lorenzo de' Medici, founded the grand-ducal line.

Like the aristocracy of Milan, Ferrara, and Mantua, the Medici did not rule by the strength of armies but by their financial power. Giovanni began the tradition of magnanimous patronage, donating grand and beneficial works to a grateful people to reinforce the family's popularity.

The Medici family was so powerful that the popes relied on their support to maintain the ascendancy of the Church. Several of the Medici's became popes, including the unscrupulous Alexander VI, who ruled in the 1490s, and Pope Clement VII, who endured the Sack of Rome by Habsburg forces in 1527

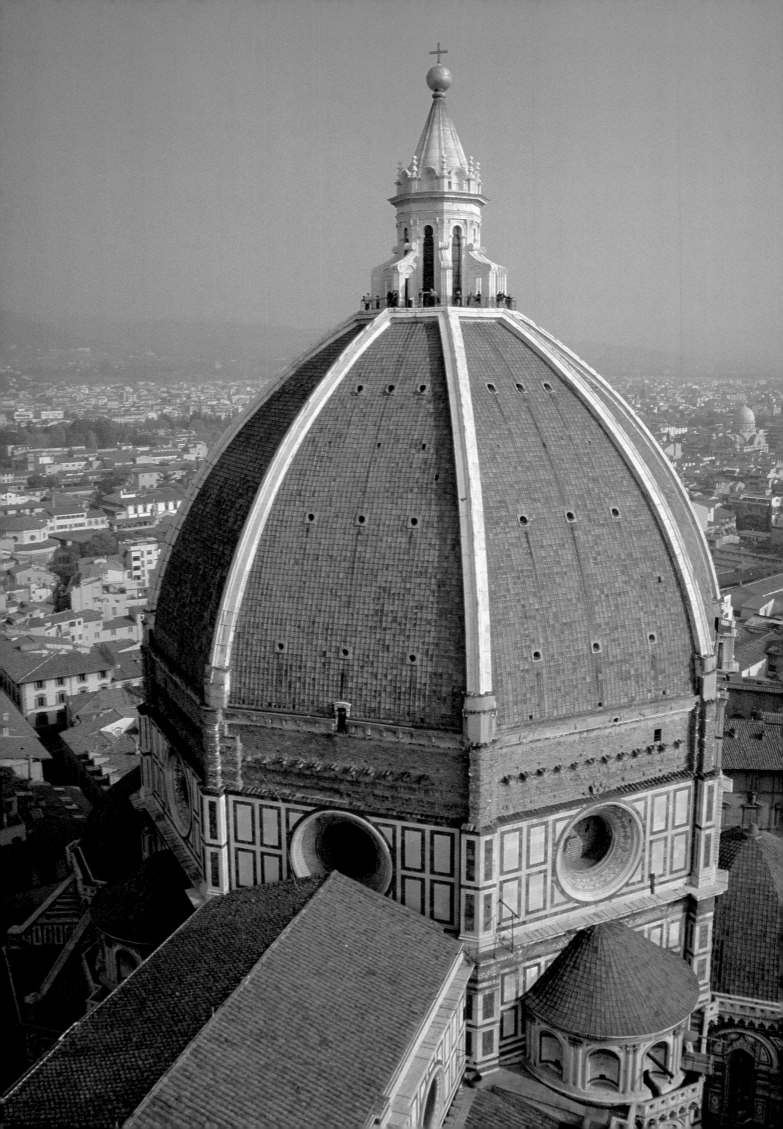

(a downtrodden Clement VII agreed to crown Charles V Holy Roman Emperor barely three years after the Sack).

One of the most prominent patrons of the High Renaissance was Pope Leo X, son of Lorenzo the Magnificent. Lorenzo the Magnificent, grandson of Cosimo de' Medici, took public works to a new height. Lorenzo established the Platonic Academy of Philosophy, and spent vast sums on buildings and festivals to gain the affection of the Florentine people. He also revitalized the academy of art instruction which influenced centuries of European artists. Since the artisan guild in Florence was a loose business association rather than a strict union, the artists of the Early Renaissance had unprecedented freedom to experiment with new forms of expression.

## ARCHITECTURE

In 1401 two young Florentine artists, Filippo Brunelleschi and Donatello, traveled to Rome to study the ancient monuments. They drew and measured every piece of antiquity they could find, including the Pantheon which inspired Brunelleschi's design for the immense dome of Florence Cathedral. The two artists also directly observed the forms of Doric, Ionic, and Corinthian styles that they would later compare to Vitruvius's descriptions in *De architectura*.

Brunelleschi developed the technique of linear perspective out of the need for accuracy in his drawings. It was not merely the appearance of the ruins, such as the ratio between the parts, but their structure and the support systems he wanted to record. In order to engineer his own buildings, he had to be certain that his measurements and plans were accurate.

Linear perspective allowed Brunelleschi to reproduce exactly what he saw. The technique established a scientific structure that artists could use to duplicate their observations of the physical world. When a room is viewed from a fixed standpoint, all of the lines that indicate depth (those that seem to recede into the distance) are set at an angle that makes them seem to meet eventually in a single point on the horizon. In order to create the perfect illusion of an interior or a round dome, a single vanishing point can be chosen, and as long as the vertical lines are absolutely parallel, the perspective will be perfect.

By thoroughly mastering the designs of ancient structures, Brunelleschi was able to improve upon the originals. New engineering methods made it possible to combine forms and motifs in ways the ancients could not. Brunelleschi used his knowledge of classical forms to solve the decades-old problem of constructing the dome for Florence Cathedral. By 1400 the Cathedral had been completed except for the

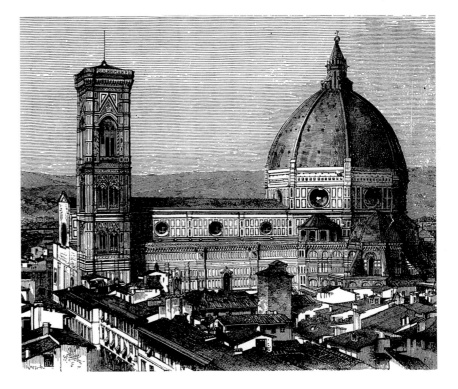

**The Dome of Florence Cathedral**

*FILIPPO BRUNELLESCHI, 1420–36; plan by Arnolfo di Cambio, 1296; lantern completed late fifteenth century. Florence.* Brunelleschi's octagonal dome, shown here in an early engraving as well as a modern photograph, was the largest built in Western Europe since the Pantheon. The unique herringbone pattern of the bricks carries the enormous weight away from the structural supports of the ribbing, while the lantern at the top weights the dome, holding the ribs together.

## The Last Supper

*ANDREA DEL CASTAGNO, 1447; fresco. Refractory wall of Sant' Apollonia, Florence.*

The scene of the Last Supper was often depicted on the walls of the refractory (dining room) in monasteries. Here, Castagno paints the illusion of the room continuing into space, as if the Last Supper was actually taking place alongside the monks.

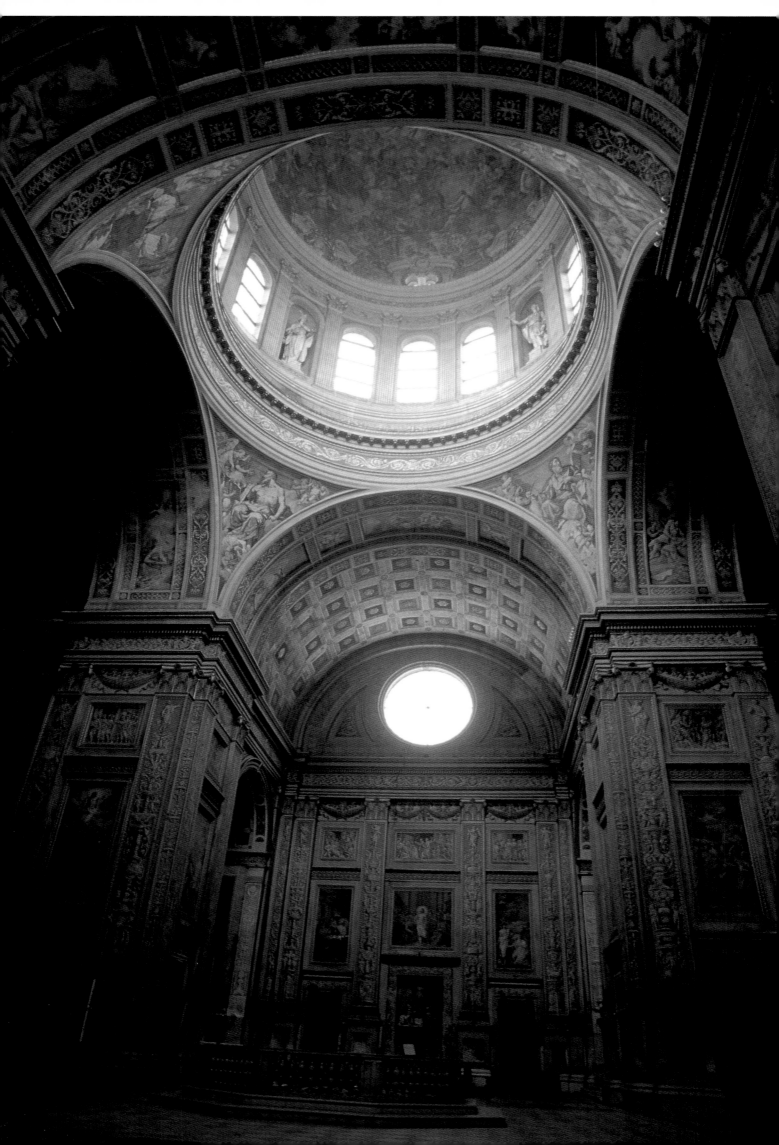

(*De architectura*) and was inspired by Vitruvius's anthropomorphic descriptions of classical forms which characterized the plain strength of the Doric column as "masculine," while the Ionic was "feminine" in its slender grace.

Alberti wrote a number of important theoretical works on art and architecture (*Della pittura*, 1436, and *De re aedificatoria libri X*, 1452) in which he urged artists to chose subjects based on ancient literature and models. He drew his examples from the descriptions first lauded by Pliny in his *Natural History*.

In the preface of *Della pittura*, Alberti raved about the new dome that was being erected over Florence Cathedral, and he proclaimed that Brunelleschi's dome outdid antiquity. Alberti believed that the benefits of modern technology enabled artists not only to rival classical perfection but improve upon it. Alberti's key contribution was his own system of deploying classical elements, and his popular architectural designs epitomized the Renaissance tendency to adapt and transform classical motifs.

It was common in that day to simply build a new façade to refurbish existing structures. Alberti's façade

for the Palazzo Rucellai in Florence (c. 1450s) unified a group of three medieval-style houses. Based on Vitruvius's treatise, Alberti used a different classical order of columns for each story: Tuscan (an adaptation of the Doric order) for the ground floor, Ionic (with the addition of acanthus leaves usually seen in Corinthian) for the second floor, and pure Corinthian on the third floor.

The demands of classical proportions sometimes clashed with the needs of the Church. Architects from the early decades of the Renaissance, such as Brunelleschi and Alberti, to Mannerist architects Michelangelo and Vasari all designed plans for centrally harmonious churches. But the clergy was insistent in their demands for a traditional cross-shaped church because it was more practical for Christian religious services.

When Alberti designed Sant' Andrea in Mantua (1470), he retained the elongated nave but refused to compromise on the façade. The temple pediment is supported by four huge pilasters and a triumphal arch, forming a façade that is markedly shorter than the rest of the basilica.

## Façade, Santa Maria Novella

*LEON BATTISTA ALBERTI, c. 1456–70. Florence.*
In this grand façade, Alberti combined classical pediments (attached columns) with the form of a Roman triumphal arch. The scroll-buttresses accent the centrally balanced design.

## Nave, Sant' Andrea

*LEON BATTISTA ALBERTI, 1470. Mantua.*
Alberti decided to omit the medieval colonnades of the nave, leaving the space a vast open hall. The deep coffers in the vaults are also reminiscent of the dense enclosing masses of Roman architecture.

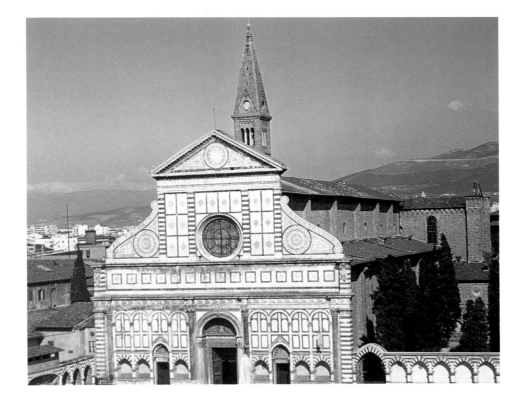

## SCULPTURE

One of the first sculptural milestones marking the beginning of the Early Renaissance was the competition for the North Doors on the Baptistery of Florence Cathedral. According to Lorenzo Ghiberti's account, his panel easily beat those offered by scores of other artists, including Brunelleschi. The commission was highly profitable and the reliefs took over twenty years to complete (1403–24). When the North Doors were completed, Ghiberti was immediately awarded another commission for the East Doors of the Baptistery, which he worked on from 1425–52.

Ghiberti's sculptural reliefs on the two sets of Baptistery doors clearly show the transition from medieval conventions to the innovations of the Renaissance. In the first set of reliefs (North Doors), the figures are set on the same plane, relying on lines of folded drapery to create a sense of depth and motion. The tableaus are contained within quatrefoil frames that lend the same effect as the border on a manuscript illustration.

In the second set of doors (East Doors), each scene from the Old Testament fills the entire panel. The space is rendered in a convincing manner, and the illusion of depth is effectively created by Ghiberti in his use of pictorial perspective. The architecturally sound structures recede into the distance with the relief gradually becoming a lightly etched line in the background.

Though the figures are arrayed in a frieze-like row in the foreground, they pose naturally with lifelike gestures, and their sculptural roundness creates an astonishing sensation of depth. Ghiberti based the anatomy on his extensive collection of ancient sculpture, bronzes, and coins gathered through his long career. His reliefs were only the beginning of a new realism inspired by the study of man and nature.

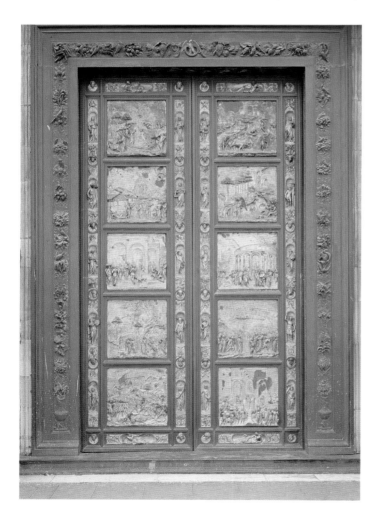

### The Gates of Paradise
### (East Doors of the Baptistery)

LORENZO GHIBERTI, 1425–52; gilded bronze. Baptistery, Florence.
Ghiberti was deeply influenced by Alberti's theories
(espoused in his *De Pictura* [*On Painting*], 1435) when he
designed these doors. When Michelangelo said they were
worthy to be the gates of Paradise, the nickname stuck.

### Self-Portrait

LORENZO GHIBERTI, 1425–52; from Gates of Paradise
(East Doors of the Baptistery); gilded bronze. Baptistery, Florence.
Ghiberti's self-portrait in one of the small medallions
on the doors represents the transition from the middle
ages to the Renaissance. Here, Ghiberti renders himself
as a humble artisan of the middle ages, yet his pride on
winning the coveted commission for the Baptistery doors
is thoroughly Renaissance in its self-congratulation.

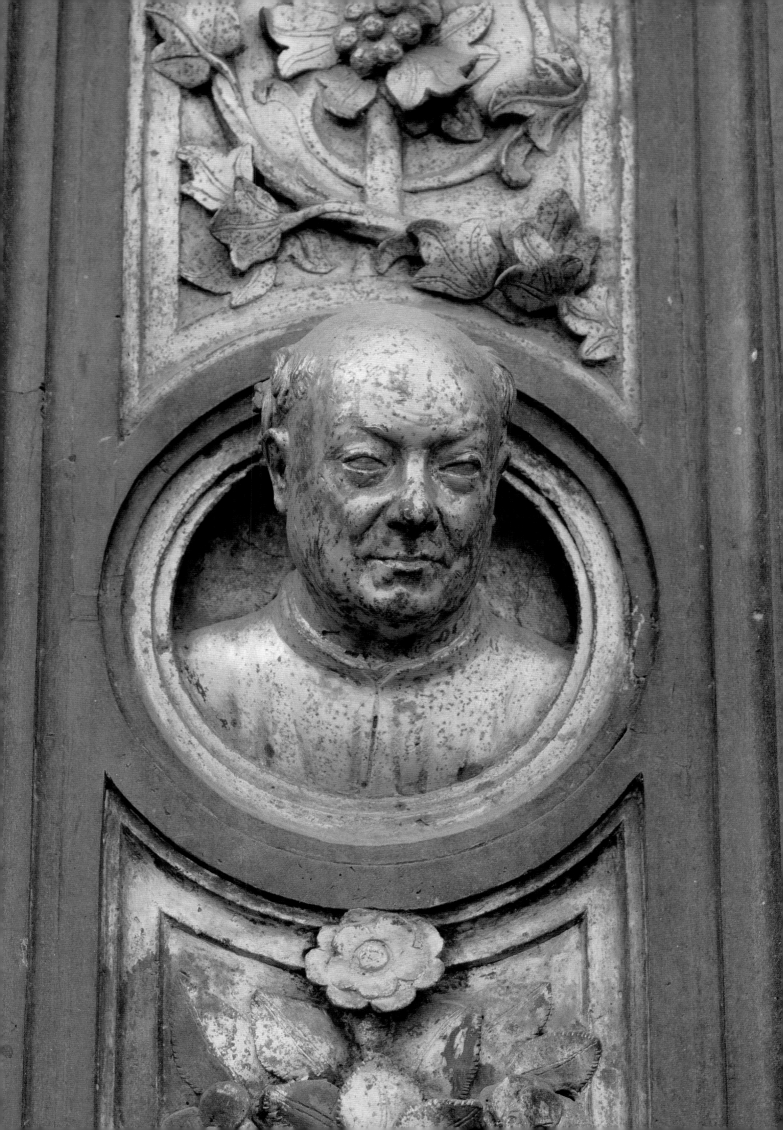

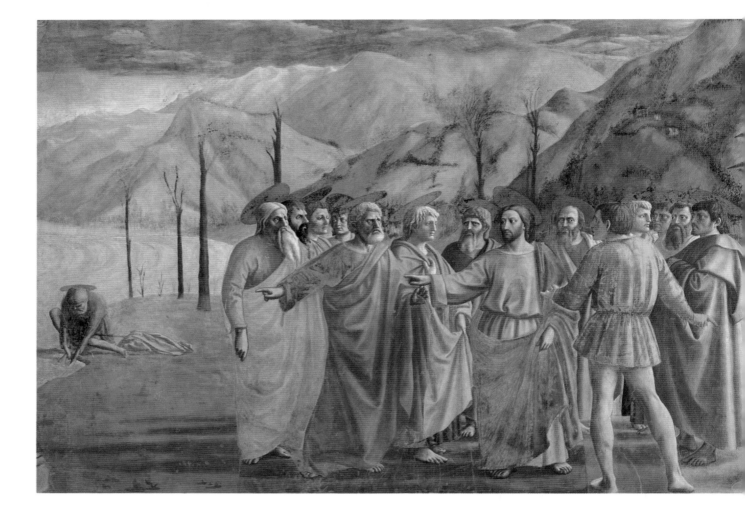

## PERSPECTIVE

The art of painting was transformed in the Early Renaissance by Brunelleschi's discovery of linear perspective, allowing painters to create a three-dimensional space on a flat plane. Along with linear perspective, the technique of atmospheric perspective was also developed to enhance the illusion of distance through light and color. Masaccio's *The Tribute Money* (c. 1425) is a perfect example of Early Renaissance exploration of atmospheric effects, with distance suggested by intensifying the blue tones of the background objects.

Renaissance artists moved away from the decorative surfaces of medieval paintings, which emphasized line, color, and gold leaf highlights. Lacking the technique of perspective, medieval artists simply stacked the figures on top of one another. Masaccio's figures, on the

other hand, seem to stand convincingly on the ground and move naturally as if on a stage.

One Florentine painter, Paolo Uccello, discovered perspective when he was a mature artist. He eagerly incorporated this technique into his medieval paintings with varying degrees of success. Uccello's *The Battle of San Romano* was painted for the Palazzo Medici to commemorate the Florentine victory over the Sienese in 1432. The surface decoration and the uptilted background evoke an earlier age of painting, but the composition is enlivened by the foreshortened lances and fallen soldiers. Uccello had a passion for creating geometrically solid forms.

Piero della Francesca was another Florentine painter who rose to the challenge of perfecting the appearance of geometrical forms and architectural

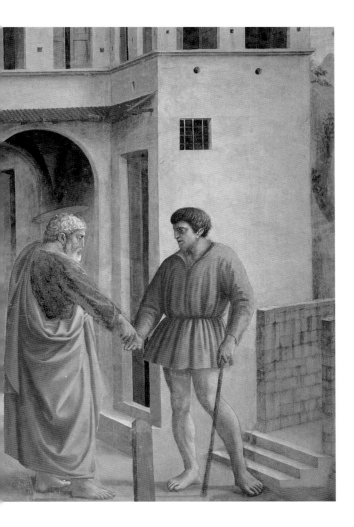

## The Tribute Money

*MASACCIO, c. 1425; fresco.*

*Brancacci Chapel, Santa Maria del Carmine, Florence.*

Masaccio, along with Brunelleschi and
Donatello, helped to formulate the principles
of perspective and foreshortening for genera-
tions of Renaissance artists. Vasari praised
Masaccio's ability to reproduce structures
and figures exactly as those created naturally.

## The Battle of San Romano

*PAOLO UCCELLO, c. 1445; panel; 6 ft. x 10 ft. 6 in.*

*(182.8 x 203.2 cm). Uffizi Gallery, Florence.*

The constant warfare between ruling nobles led
to commissions for large, commemorative battle
scenes. Uccello, like most Renaissance artists,
chose a symbolic interpretation: the relatively
minor skirmish of San Romano resembles the
stately procession of a contemporary tournament.

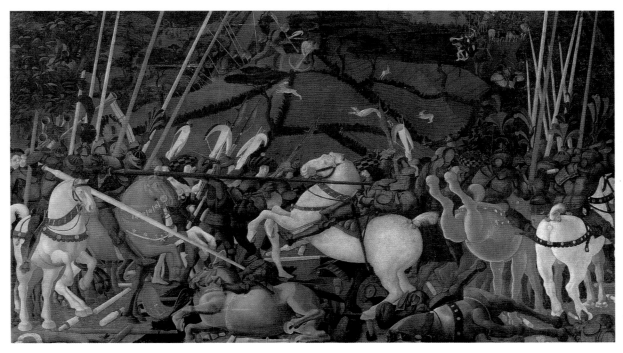

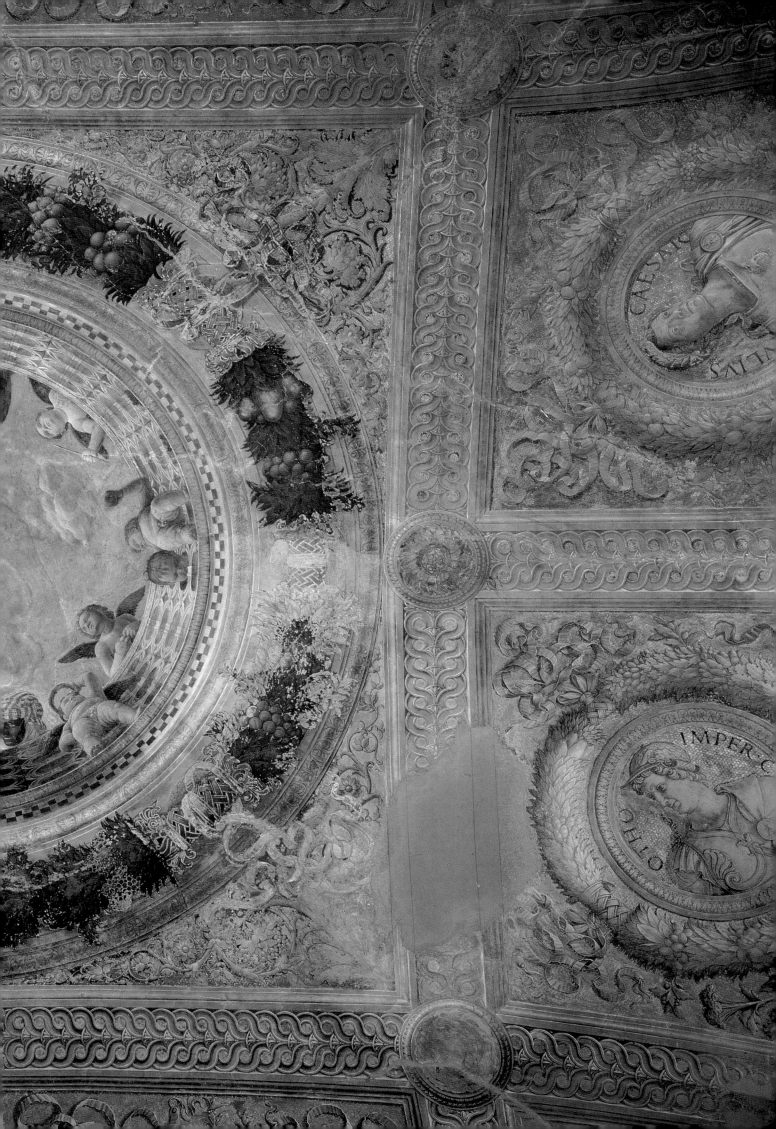

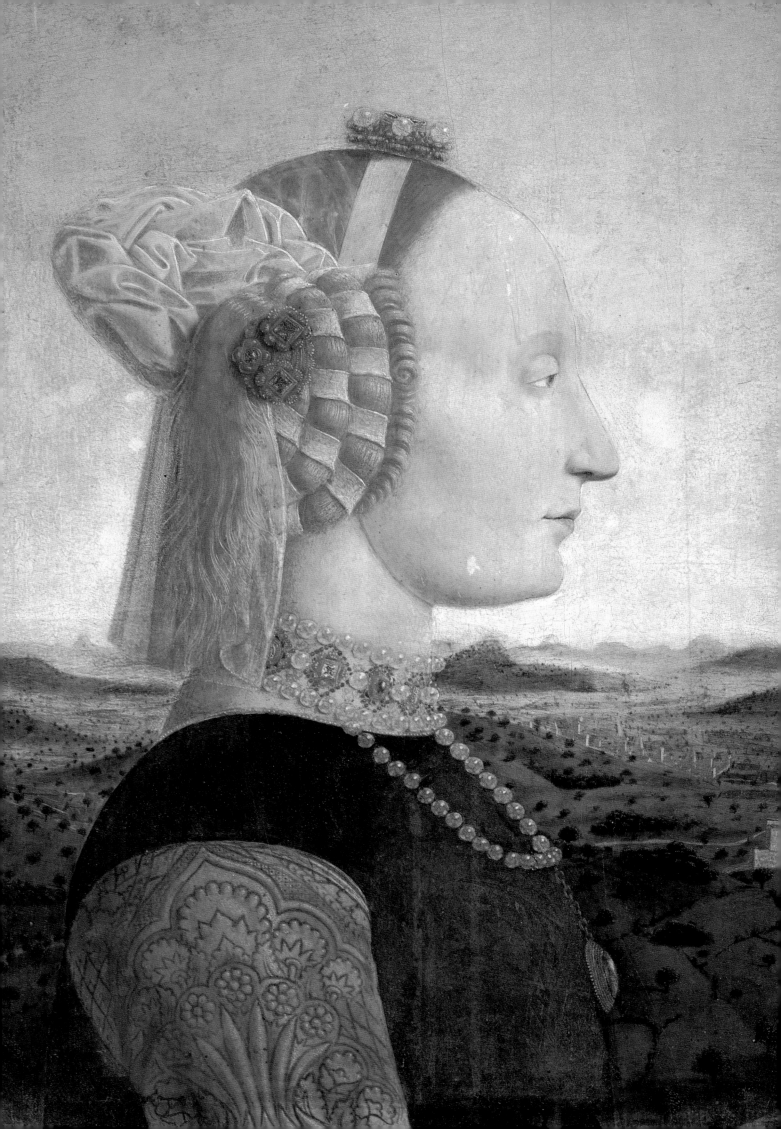

## Madonna and Child

*FRA FILIPPO LIPPI, c. 1452; panel; diameter 53 in. (134.6 cm). Pitti Gallery, Florence.*

Fra Filippo Lippi was a monk yet he interprets his subject in a rather worldly manner.
The interior is patterned on the home of a well-to-do Florentine, and scholars have
speculated that the identity of the model for the Madonna was Lippi's own mistress, Lucretia.

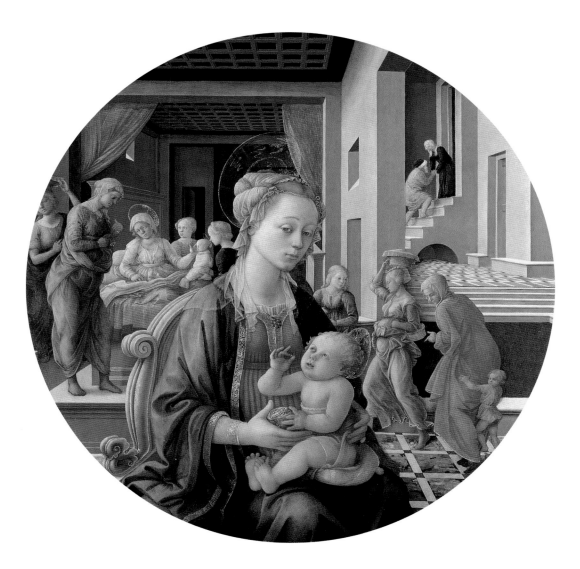

## Portrait of Battista Sforza

*PIERO DELLA FRANCESCA, after 1474; panel; 18½ x 13 in. (46.9 x 33 cm). Uffizi Gallery, Florence.*

Portraits were extremely popular during the Renaissance, from full-length
figures on canvas to miniature reliefs on medallions. Couples often sat for
portraits shortly after their wedding, and royalty usually insisted on seeing
a portrait when considering an international alliance through marriage.

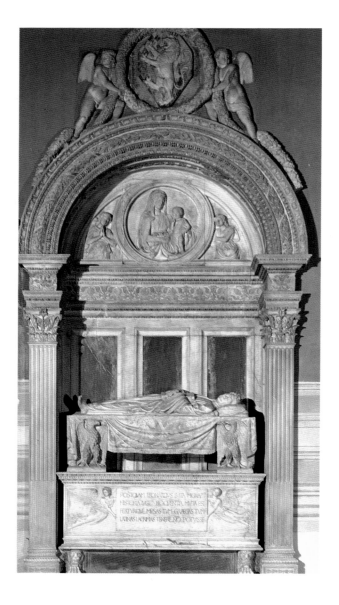

## The Tomb of Leonardo Bruni

*BERNARDO ROSSELLINO, c. 1445;*

*colored marble. Santa Croce, Florence.*

Throughout the middle ages and the Renaissance,
funerary monuments provided endless commissions
for reliefs on sarcophagi and simple tomb slabs
as well as magnificent architectural monuments.

## Hercules and the Hydra

*ANTONIO DI POLLAIUOLO, c. 1460;*

*panel; 6 ft.¾ in. x 4 ft.¾ in.*

*(184.7 x 123.8 cm). Uffizi Gallery, Florence.*

Hercules was a popular figure during
the Renaissance because of his heroic
associations. The Florentine people
considered Hercules their special
protector, just as the Spartans revered
Ares, and the Athenians claimed Athena
as their patron goddess.

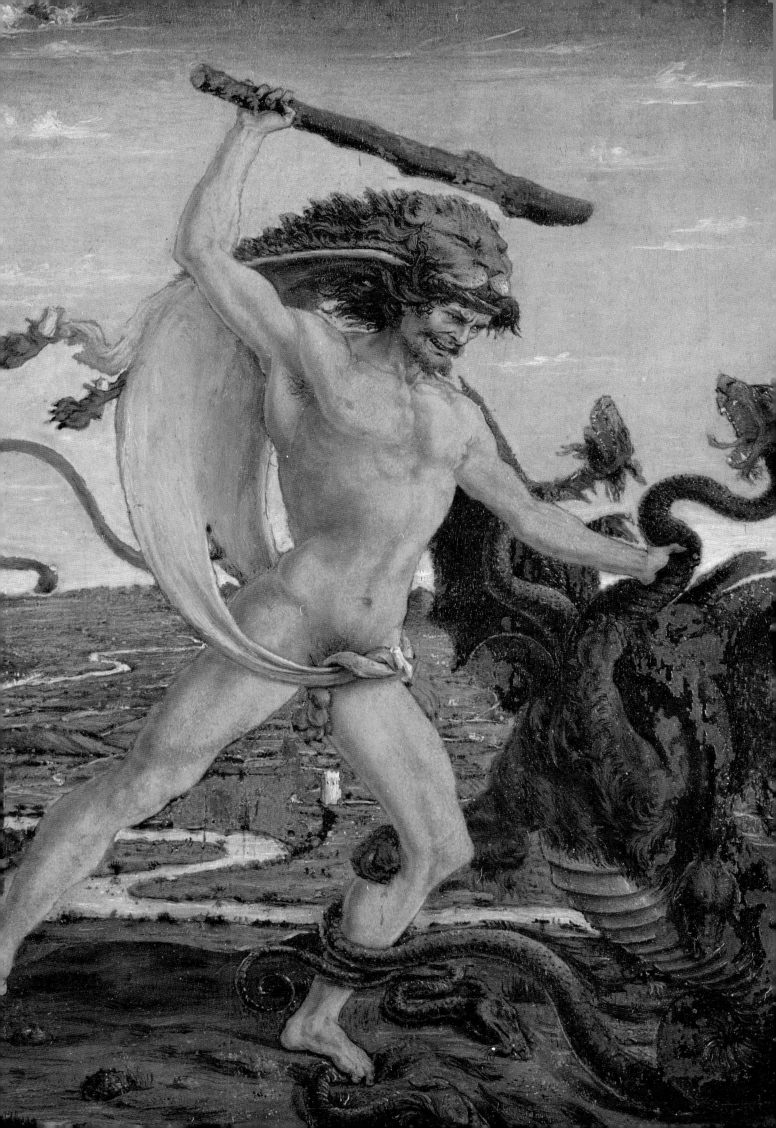

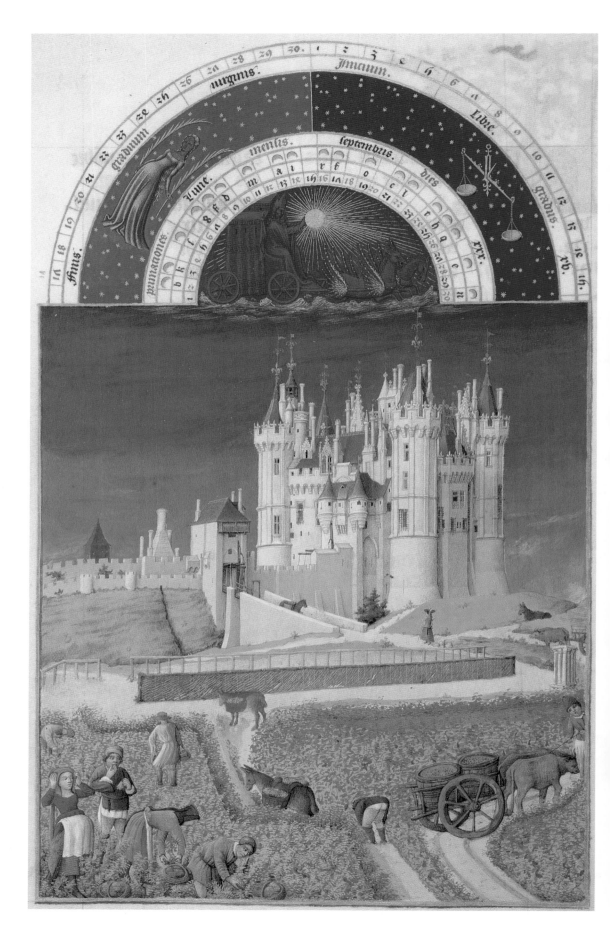

## Les Très Riches Heures du Duc de Berry

*The LIMBOURG BROTHERS, 1413–1416; illumination. Musée Conde, Chantilly.*

The pictures for this renowned Book of Hours are represented by seasonal tasks in each of the twelve months. In February a farmyard is shown, with the ground covered by snow and a peasant in the distance with a donkey pulling firewood toward the village; in May, a group of aristocrats ride out on their elaborately decked steeds to enjoy the spring festival. Shown here is the grape harvest, representing the month of September.

# THE NORTHERN RENAISSANCE

Medieval traditions lingered into the fifteenth century in northern Europe, influencing the development of Northern Renaissance art and architecture. Northern artists often combined Renaissance techniques of perspective and realism with typically Gothic elements, such as pointed arches and the meticulous detail usually found in manuscript illumination. This blend of medievalism and Renaissance realism is exemplified by the gorgeous illustrations in the Limbourg Brothers' Book of Hours for the Duke of Berry, brother of the king of France and Philip the Bold of Burgundy. The Book of Hours contained eight liturgical passages, from Matins to Compline, which were supposed to be read throughout the day. The Limbourg Brothers enlivened this religious text with aristocratic scenes of pleasure.

The Italian style of Renaissance art was carried by merchants and foreign businessmen into the north. The Flemish cities of Tournai, Ghent, and Bruges were centers of international commerce. Bruges rivaled Florence in its wealth derived from the wool trade and international banking. The Duke of Burgundy made Bruges his capital and, from the early fifteenth century, the city was the home of the most powerful rulers in the north. Through marriage, the Dukes of Burgundy controlled the Low Countries and lands that stretched from the Rhône River to the North Sea.

This kingdom lasted until the death of Charles the Bold in 1477. Then Maximilian of Habsburg married Mary of Burgundy, taking the Netherlands under the rule of the Holy Roman Empire and allowing the French to annex the southern lands.

Flemish painters were relatively uninspired by the mythological subjects and classical symmetries of Italian art. Most of the Early Renaissance art in the

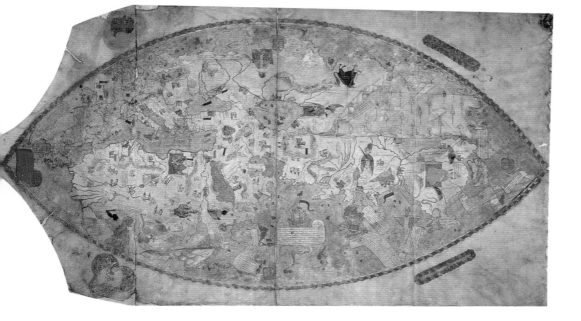

**Plan of the World**

*PAOLO TOSCANELLI, c. 1450s; tempera on parchment. Biblioteca Nazionale, Florence.* This view of the world was created before the great sea voyages that would lead Europeans to discover the western hemisphere. Note that Italy is shown at the center of the world.

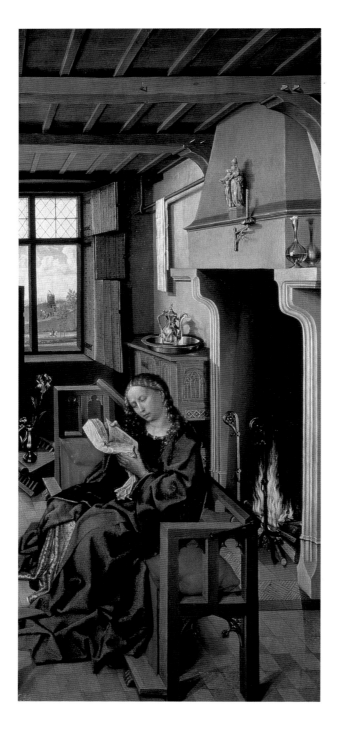

**Saint Barbara**

*ROBERT CHAMPIN (Master of Flemalle), c. 1438;*

*tempera and oil on wood; 39⅜ x 18¼ in. (101 x 47 cm). Prado, Madrid.*

Flemish painters were the first to experiment with three-dimensional representation. Though Champin was not familiar with the Italian technique of perspective, he successfully created a tangible depth through the physicality of the objects.

north was devoted to religious subjects, as northern artists experimented with increasingly realistic detail and the optical illusions of atmospheric perspective.

In France, artists were employed by the secular courts of the dukes of Berry, Bourbon, and Nemours. These artists followed the lead of the Flemish masters, especially in the development of realistic portraiture, but they were slower to master the use of oil paints. German artists were deeply under the influence of the Flemish masters, and they continued to emphasize the flamboyant Gothic forms and frieze-like compositions of the middle ages. By the middle of the fifteenth century, the influence of the Flemish masters had spread as far south as Spain.

## ROBERT CHAMPIN

The Flemish artist Robert Champin (often referred to as the Master of Flemalle) was the first to switch from egg-based paint to oil-pigments. Subsequent generations of Flemish artists would learn oil painting while training in the well-organized art guilds. Young artists started at the bottom, learning how to mix colors and varnishes, and performing the lesser tasks required by their painting master.

The oil medium gave northern paintings a rich luminous surface and depth of reflected light that tempera-based pigment lacked. Compared to the northern Renaissance paintings, the Italian works—despite their technical skill—retained a rather flat, patterned surface.

*Saint Barbara* (c. 1438), by the Master of Flemalle, retains the medieval convolutions of linear perspective. Yet this work embodies the Renaissance ideals of realism in the forms and textures of the objects. Shadows carefully imitate the slanting sunlight into a room, and the colors are subtle and vary in tone to indicate volume and mass, unlike the stylized flat planes of color found in medieval painting.

Indications of Renaissance humanism also appear in the details of the scenes. The tower of St. Barbara is cluttered with everyday objects from a typical middle-class Flemish home, and the chalice, the wafer, and the peacock feather are all symbols of St. Barbara's

Christian devotion. Flemish painters believed that the best way to approximate God was via the power of sight, for it was understood He could see everything, great and small. Thus each detail reveals the divine presence by its very existence.

## JAN VAN EYCK

Jan van Eyck is often credited with being the first painter to use oil pigments, but the Master of Flemalle's Merode Altarpiece was completed four years before the Ghent Altarpiece (1432), the first work that can be definitively attributed to van Eyck. The style of van Eyck's altarpiece is very similar to the Merode Altarpiece: both have spatial depth and sharply shadowed folds of drapery that suggest volume much better than the looping, curving lines in medieval illuminations.

The space is loosely organized by conflicting vanishing points, yet van Eyck produces a splendid illusion of diminishing distance in the landscape through his use of atmospheric perspective. Background detail, such as the castle and mountains, are blurred by a blue-gray haze. The colors seem to merge into shadowy masses in exactly the same way that dust in the air obscures our view of distant objects. This could only be done convincingly with oil-based pigment, which allowed the artist to apply semi-translucent layers of different tones.

Northern artists applied Renaissance realism to every aspect of their paintings, especially in their portraiture. Before 1420 most painters limited themselves to profile views that were usually done on altarpieces to commemorate the donors. These donor portraits increased in size and prominence until the portrait became an independent genre.

Though portrait busts were common from the Roman era, there were no painted portraits for artists to study. The Italians preferred the profile view throughout the Early Renaissance, while the Flemish artists quickly mastered the full-face and three-quarter views. Many artists, from Holbein to Piero della Francesca, produced memorable miniature portraits.

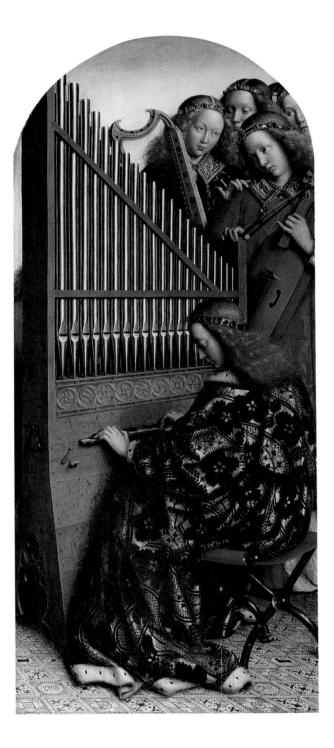

### Organ from The Ghent Altarpiece

*JAN VAN EYCK, 1432; tempera and oil on wood; 11 ft. x 7 ft. 3 in. (335.2 x 220.9 cm). St. Bavo, Ghent, Belgium.*

Van Eyck creates the illusion of depth through intricate patterns in the floor and robe, and in the shine of gold on the organ pipes. Upon closer examination, there are different vanishing points for the floor tiles as compared to the organ.

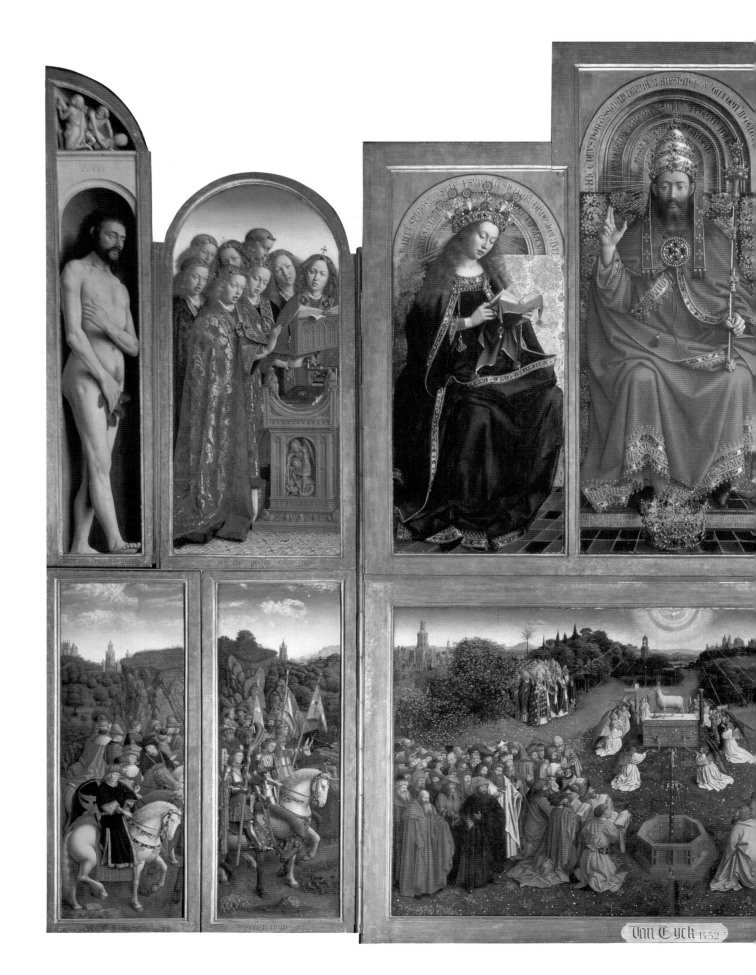

Van Eyck 1432

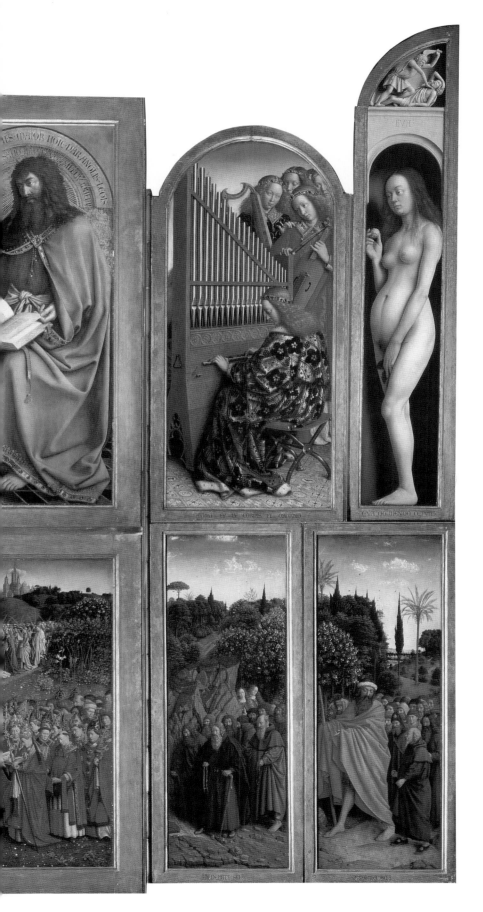

## The Ghent Altarpiece

*JAN VAN EYCK, 1432; tempera and oil on wood;*
*11 ft. x 7 ft. 3 in. (335.2 x 220.9 cm). St. Bavo, Ghent.*
The central body of this enormous altar has
two hinged wings that close to reveal a scene
of the Annunciation. In all, there are twenty
panels of varying shapes and sizes which van
Eyck treats as niches to hold his sculptural figures.

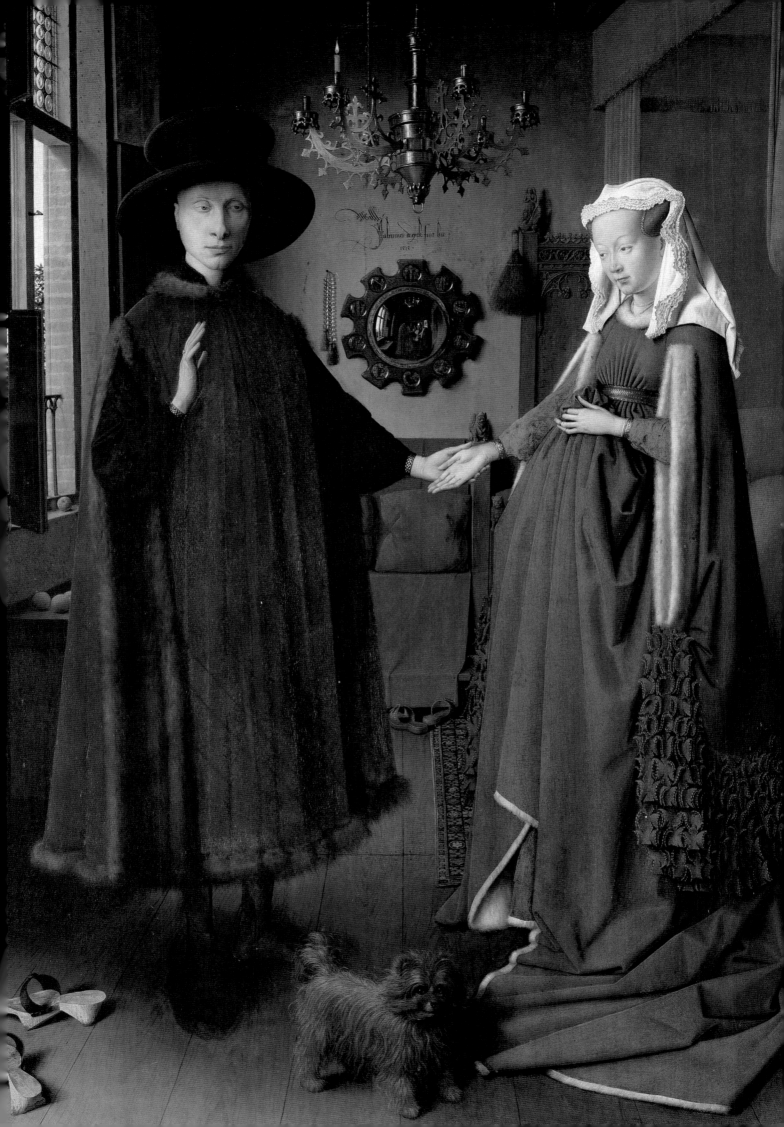

Since much of the wealth and power was distributed among the Flemish bourgeoisie, artists tended to work for their fellow citizens rather than the aristocracy. This new empowered class of burghers wanted realistic portraits of themselves. Northern artists had to walk a fine line, painting a recognizable likeness that emphasized the patron's better qualities. Jan van Eyck's portrait of Canon van der Paele (1436) is quite realistic, right down to the wrinkled jowls and balding head. Even the hands appear veined and old.

Perhaps the best known portrait by van Eyck was commissioned by an Italian merchant of the Arnolfini family. This portrait of the wedding couple follows the Flemish tendency to focus on the nuclear family rather than extended relations (like the aristocratic Medici family). Among the middle class, weddings were made by personal preference instead of as political alliances.

In the mirror, Jan van Eyck painted his own portrait along with that of another person, indicating they were witnesses to the ceremony. Van Eyck even signed over his image "Jan van Eyck was here." This literal translation of the nuptials is further carried to the couple's bare feet, indicating they stand on holy ground during the consecration of their vows. The little dog in the foreground is a symbol of loving fidelity.

## PIETER BRUEGEL

Pieter Bruegel the Elder was the last great Flemish master. With true humanist resolve, he painted what he believed to be the true condition of man, at the mercy of the unpredictable and all-powerful forces of nature.

Bruegel was considered to be a satirist. Many of his paintings can be misinterpreted as simple festival scenes. But on closer examination the dancing peasants with their kicking heels are obviously caricatures

### The Return of the Hunters

*PIETER BRUEGEL THE ELDER, 1565; oil on wood; 46 x 64 in.*
*(116.8 x 162.5 cm). Kunsthistorisches Museum, Vienna.*
Bruegel painted six scenes illustrating the seasons. In this painting, the winter snow shrouds a Flemish countryside that curiously abuts the jagged cliffs of the Alps. The painter defies the dictates of realism in order to solve the compositional need to balance the white diagonal mass of the hillside in the foreground.

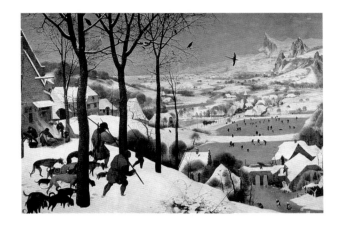

of boisterous fun. In *The Battle Between Carnival and Lent* (1559) the small group of penitent Christians in their brown robes are overpowered by the rollicking, riotous crowd that is enjoying carnival. Bruegel was among those who believed that festivals were simply an excuse for drunken, uncontrolled behavior.

Bruegel spent a few early years in Italy studying art, but his paintings are better known for their expression rather than proportion of line and mass. Even in his series of six paintings that beautifully commemorate the seasons, Bruegel made it clear that he chose to represent the peasant class because they were most affected by the seasonal changes.

### Giovanni Arnolfini and his Bride

*JAN VAN EYCK, 1434; tempera and oil on wood;*
*32 x 22 in. (81.2 x 55.8 cm). National Gallery, London.*
Jan van Eyck's compositions sometimes have a rigid, static quality because of the precision of his textural surfaces. Concrete detail, however, was admired in a picture that served to document Arnolfini's wedding, just as a twentieth-century marriage license would.

*FOLLOWING PAGE*

### The Battle Between Carnival and Lent

*PIETER BRUEGEL THE ELDER, 1559; oil on oakwood;*
*46 x 64¹/₈ in. (118 x 164.5 cm). Kunsthistorisches Museum, Vienna.*
Near the end of his life, Bruegel destroyed the inscriptions that originally accompanied his paintings and prints because he believed them to be too bitter and sharp in their satire. Thus it is left to the viewer to interpret each scene.

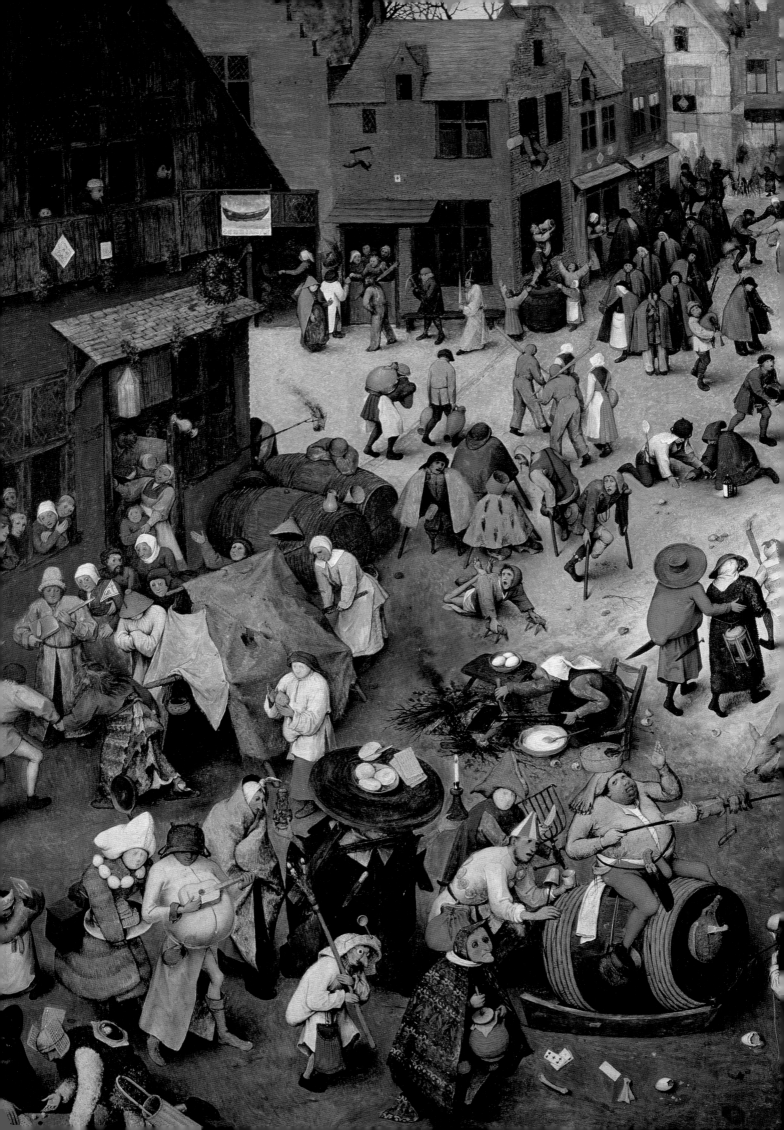

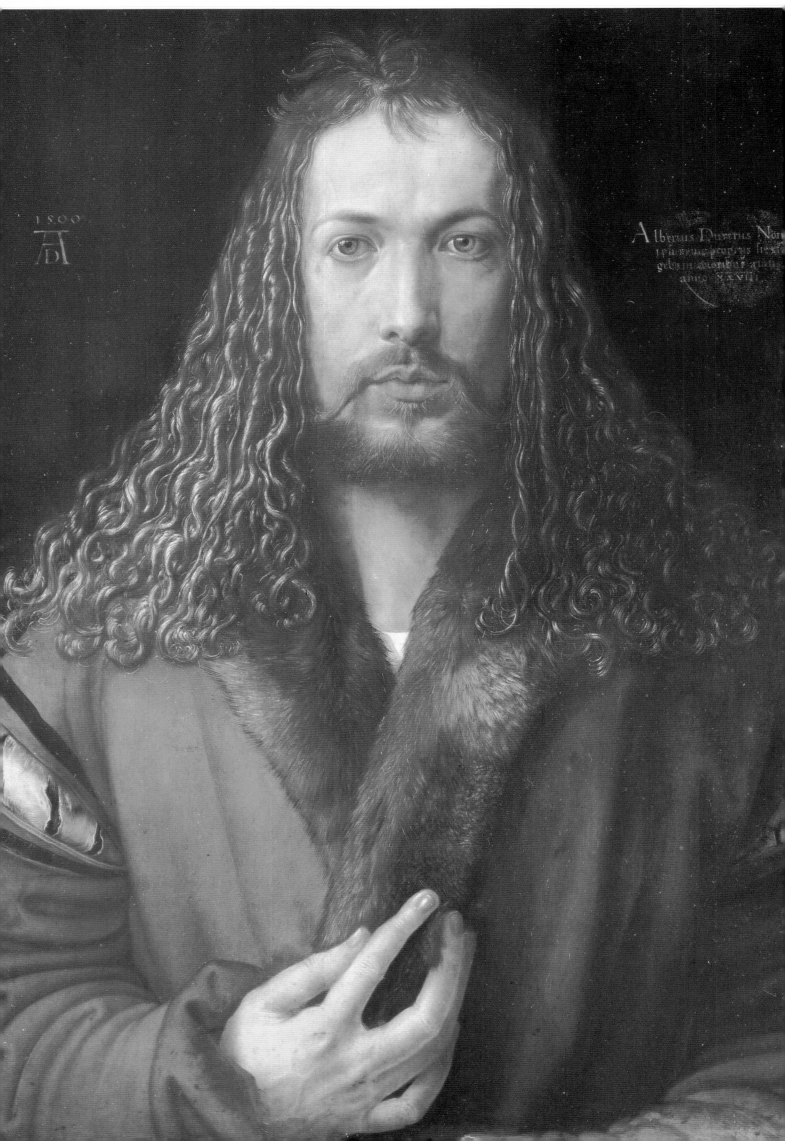

1500

AD

Albertus Durerus Nori
tebergensis proprijs sic eu
gebam coloribus aetatis
anno XXVIII

development of entirely new genres in painting, such as landscape, still life, and small domestic scenes.

Printing was key to the success of the Reformation. Not only could vernacular Bibles be made cheaply for the masses, but printed pamphlets too were ideal for conveying the theological arguments of the Protestant leaders. Even the poorest people could understand the graphic illustrations in the pamphlets portraying greedy churchmen fleecing the needy so that their crosses could be gilded with gold and their tables covered in rich foods.

## ALBRECHT DÜRER

Albrecht Dürer (1471–1528) was the best known artist to combine forms and ideals from both northern and southern Europe. Dürer's work often had a religious content, and as a young artist he was employed by the papacy. Yet by the time of his death, Dürer was a staunch supporter of the Reform.

In Germany, the wealthy merchant class maintained

### Melancholia

*ALBRECHT DÜRER, 1514; engraving;*
*9½ x 7½ in. (24.1 x 19 cm).*
*Philipps University, Marburg.*

There are so many references and allusions in this complex engraving that the meaning is difficult to interpret. Yet every detail, from the scales that hang in balance to the etched feathers on the wings, is a testimony to Dürer's talent and dexterity.

### Self-Portrait

*ALBRECHT DÜRER, 1500; oil on panel;*
*26¼ x 19¼ in. (66.6 x 48.8 cm).*
*Pinakothek, Munich.*

Dürer was one of the first artists to leave behind a series of paintings of himself. These detailed self-portraits record the relentless passage of time, marking not only physical changes in appearance but the development of artistic skill.

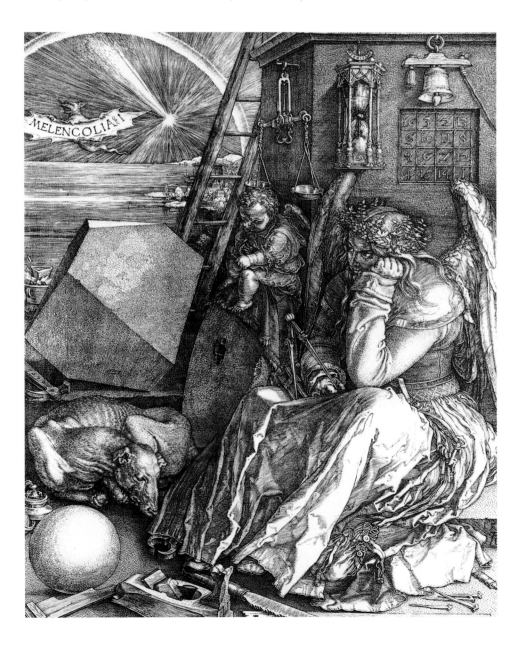

close commercial ties to Venice, and to the Neo-Platonic academy of Florence. Dürer was one of the first northern artists to travel to Italy (in 1495) to study the art of the Early Renaissance. Ten years later he again visited during his extensive travels through Europe. In his lifetime, Dürer was a well-known and admired artist with a reputation that was second only to Leonardo da Vinci. The artist's theoretical treatises on perspective, architecture, and human anatomy as well as his natural history studies rival those of the best scholars of the High Renaissance.

Dürer's well-deserved fame rested in part on the success of his favorite medium—engraving. Trained as a goldsmith, he was unusually dexterous with the tools that were used to produce woodcuts and engravings. To produce an image, the artist must force a sharp burin across the wood or metal, carving out a groove. The surface that is not cut away will transfer the ink onto paper. Dürer's strength and control in this medium is clear in the formation of tiny parallel lines.

Dürer was considered to be the artist of "everyman." He illustrated books for numerous printing presses and he sold individual prints on sheets of paper which even the average person could purchase. Early in his career, he made a set of fourteen large woodblock prints illustrating the Revelation of St. John, the last book of the Bible. Using the engraving technique of hatching lines, Dürer developed a shading effect and tones of gray not seen before, or since, in wood carving.

In his engraving of *Adam and Eve* (1504) Dürer combines technical skill with an understanding of Italian Renaissance ideals. The figures pose in an attitude reflecting the Apollo Belvedere and the Medici Venus, two popular Hellenistic statues which were often reproduced in contemporary prints.

Dürer's figures are idealized with perfect proportions: the Italian dictates of Vitruvius, for example, are clear in the figure of Adam. However the northern influence is apparent in Eve, a softer, rounder woman than those representing the Italian ideal, resembling nothing less than a plump German matron. Dürer's ability to suggest a monumental grandeur while retaining the authenticity of his scenes and subjects places him wholly in the class of High Renaissance artists.

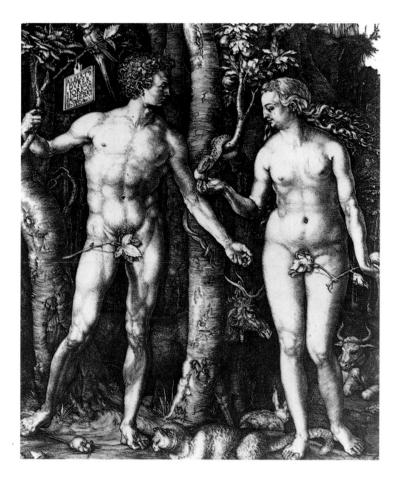

**Adam and Eve (The Fall of Man)**

*ALBRECHT DÜRER, 1504; engraving;*

*10 x 7¹/₂ in. (25.4 x 19 cm). Philipps University, Marburg.*

As the snake passes the apple to Eve, the fall of man from God's grace is symbolized as well by the face-off between the mouse and the cat in the foreground. A more scientific allusion is made via the background animals, which represent the four humors of man believed to govern health.

**The Great Piece of Turf**

*ALBRECHT DÜRER, 1503; watercolor; 16 x 12¹/₂ in.*

*(40.6 x 31.7 cm). Graphische Sammlung Albertina, Vienna.*

For both Dürer and Leonardo da Vinci, direct observation was the path to truth. Modern scientific methods of perfecting the examination of the physical world led to inventions—from telescopes to microscopes—that would improve and enhance man's sight.

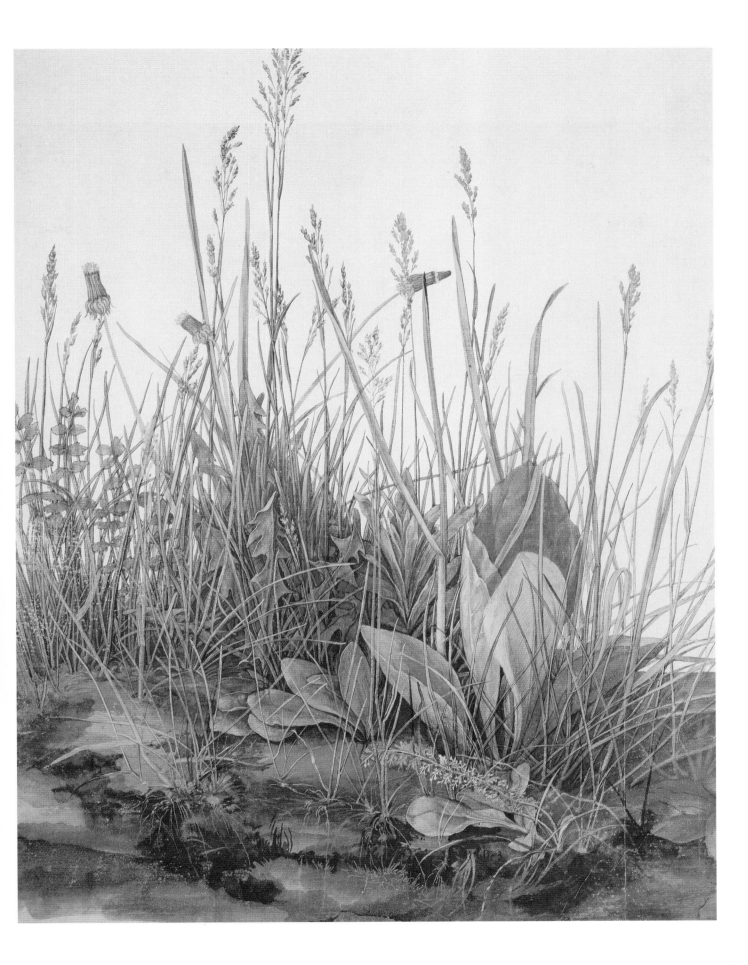

## The Sacrament
## of the Eucharist

*ROGER VAN DER WEYDEN,
1437; oil on panel. Royal
Museum of Fine Arts, Antwerp.*
Van der Weyden chose
to highlight only those
gestures and features
that expressed the
emotional impact of the
biblical narrative. For
thirty years he was the
premier painter in Brussels,
influencing generations
of artists, including those
in France and Germany.

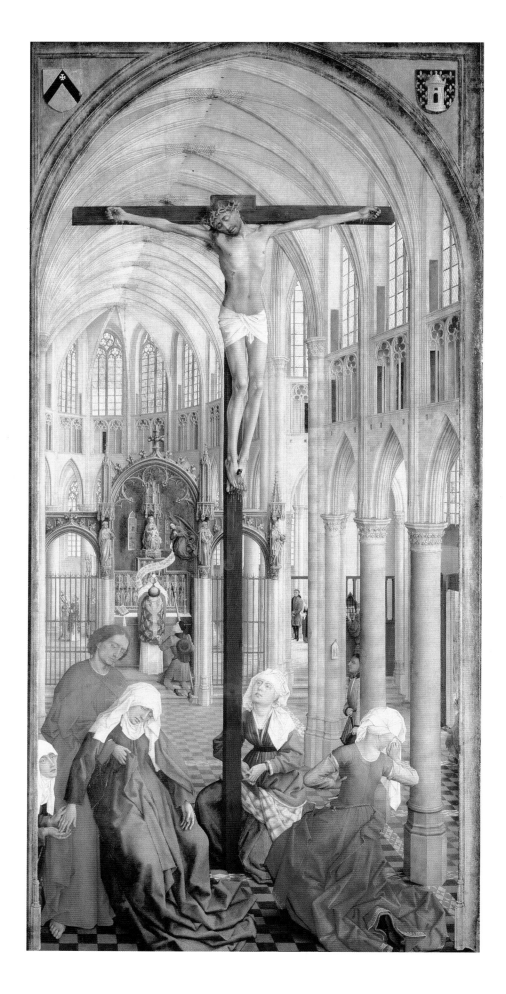

**The Nymph of the Seine**

*JEAN GOUJON, 1548–49; bas-relief. The Louvre, Paris.*

Even Goujon's rather flat reliefs, with the new Renaissance

techniques in sculpture as applied here, appear fully three-dimensional.

### Medal

*BRAMANTE's design for the new
St. Peter's Christoforo Foppa
Cardossa, 1506; bronze.
British Museum, London.*
Commemorative medals,
inspired by ancient Greek
and Roman coins, were
eagerly collected by
patrons. The reliefs are
often portraits of rulers,
but important events and
structures were also cast.

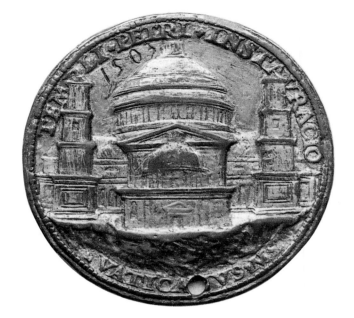

With the papal court as
the dominant patron in
Rome, many of the extra-
ordinary works of the High
Renaissance were commis-
sioned for churches and re-
ligious decoration. Some
of the most extraordinary
sculpture of the Renais-
sance was created for
tombs. Funerary monu-
ments were a tradition of
Christian art that went
back to the second century
A.D., when Roman sarcophagi were the first sculptural
works to mimick classical mythological patterns
within a Christian context.

Renaissance tombs can be found in basilicas and
cathedrals throughout Europe. Usually the deceased
was portrayed as a recumbent effigy on the lid of the
tomb. Gradually tombs acquired elaborate architec-
tural settings and were adorned with figures of alle-
gorical virtues and legendary heroes.

This centuries-old tradition was raised to new
heights by Michelangelo when he was called to Rome
in 1505 by Pope Julius II to design his tomb. Scholars
believe it was the inspiration of Michelangelo's grand
free-standing tomb—two stories high with dozens of
statues and an ornate sculptural bier—that inspired
Julius II to tear down the old basilica so a new, larger St.
Peter's could be built to house his funerary monument.

Work on Julius II's tomb turned into decades of on-
again, off-again frustration for Michelangelo, as it was
progressively downscaled to a comparatively modest

fanned out from the Piazza del Popolo. His architects
even plundered stone from the Colosseum to build a
new bridge over the Tiber that could ease congestion
from visiting pilgrims.

Thus the stage was set for the emergence of High
Renaissance patrons. Pope Julius II (1503–17) was a
tireless patron, and usually had several major projects
in progress simultaneously. Like Sixtus IV, Julius was
also a major military commander, and set about pro-
tecting the entire Italian peninsula against French and
Spanish invaders. He made the borders of the papal
states so secure as to seem impregnable.

The brief period of the High Renaissance was in-
fused with a sense of grandiosity that was not seen in
the earlier Florentine work. Pope Julius II undertook
to rebuild St. Peter's in Rome in a leap of unprece-
dented daring and disregard for tradition. The ancient
church had housed the shrine of St. Peter for cen-
turies, and the site was considered to be consecrated by
generations of ecclesiastics.

Julius II prevailed in his grand scheme, however, and
by 1506 the old basilica of St. Peter's had been torn
down and foundation stones laid for the new piers of
the crossing. The project was popular among the
craftsmen of Italy because it employed more than
2,500 workmen. (Ironically, this magnificent display of
papal devotion would later help spark the
Reformation, dividing Christendom forever over the-
ological questions of the price of redemption.)

### Street Plan for Rome

*DANTI IGNAZIO, c. 1590. Biblioteca Apostolica,
Galleria delle Carte Geografiche, Vatican, Rome.*
The great Aurelian Wall from the third century A.D.,
which can be seen in this bird's-eye view, encloses a much
larger area than was inhabited during the Renaissance. The
unfinished basilica of St. Peter's is on the lower left-hand side.

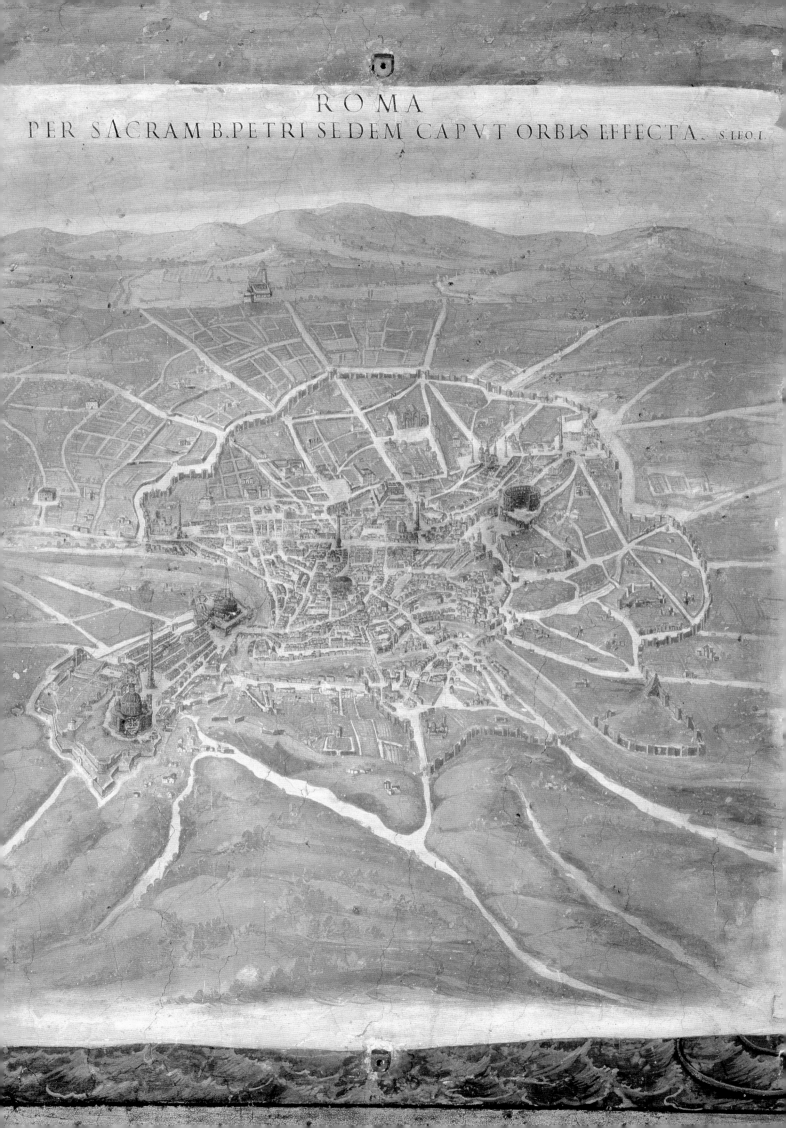

ROMA

PER SACRAM B. PETRI SEDEM CAPVT ORBIS EFFECTA.    S. LEO. I.

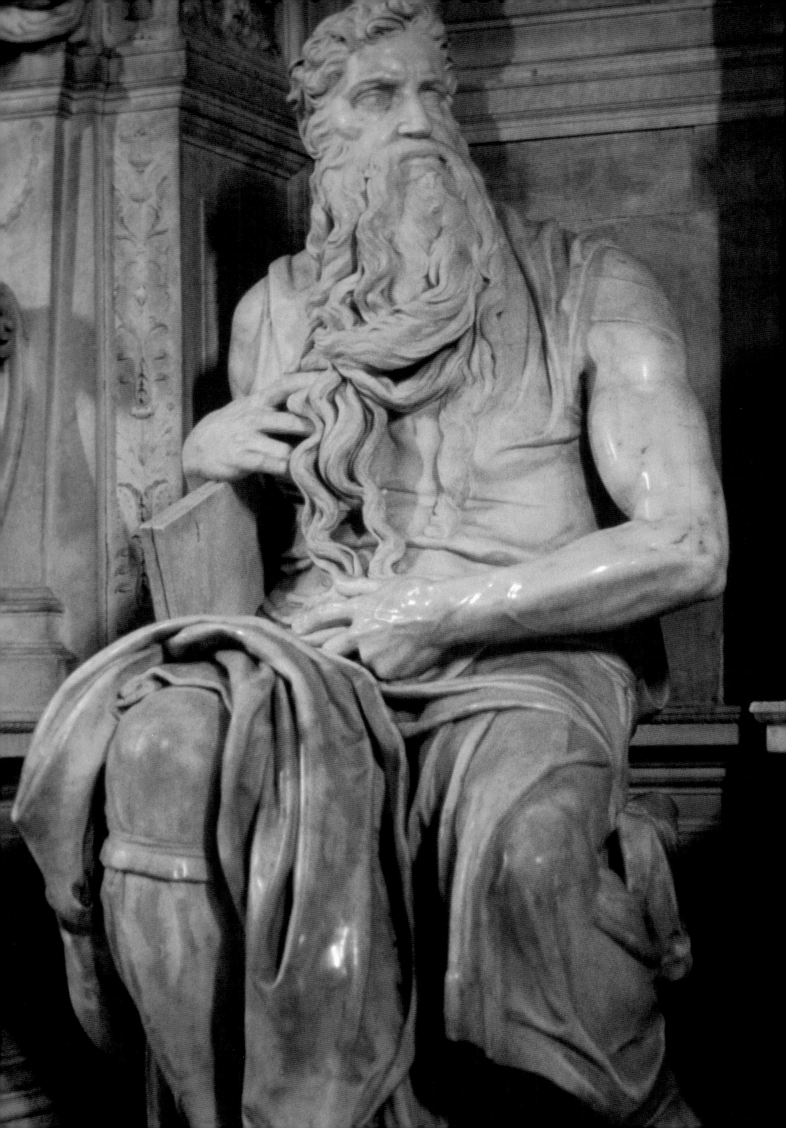

wall tomb in San Pietro in Vincoli, Rome. Even so, Michelangelo's brilliant interpretation of the funerary tradition can be seen in a number of beautifully designed and executed tombs in the Medici Chapel for Giuliano and Lorenzo, and for the Duke of Urbino in the New Sacristy, San Lorenzo, Florence.

## MICHELANGELO

The most influential artist of the High Renaissance was Michelangelo Buonarroti (1475–1564). Contemporaries were loud in their praises and frank in their imitation of his motifs and style, and subsequent generations of artists continued to turn to Michelangelo's techniques as exemplary.

Michelangelo was first and foremost a sculptor. He spent his formative artistic years under the patronage of Lorenzo the Magnificent, Duke of Florence. At this time, the Medici family included Giuliano, who would later rule Florence, and Giovanni, who would succeed Julius II as Pope Leo X in 1517. Michelangelo lived with the family and worked in an art school that had been established in the Medici gardens opposite the Church of San Marco. The young sculptor was able to study the great collection of the Medici family, which included works of ancient sculpture, cameos, medals, and Early Renaissance art.

Michelangelo worked differently from other master sculptors, such as Ghiberti and Donatello, who first created wax models and then added on material in order to bring out the effects of light and proportion. Michelangelo sculpted by carving away the marble surrounding the figure which he envisioned trapped inside.

While still in Florence, Michelangelo received his first commission from Rome for a sculpture for St. Peter's. *The Pietà* (1498–99) was acknowledged as an outstanding work from the moment it was revealed to

### Moses

*MICHELANGELO, c. 1515; marble. S. Pietro in Vincoli, Rome.*

This statue was carved as part of Michelangelo's second design for Julius II's grand tomb. Such a dynamic figure was intended to be seen from below, but in the final version of the tomb the statue is set at eye level, distorting the superb shadowing effects.

### Pietà

*MICHELANGELO, 1498–1500; marble. St. Peter's, Vatican, Rome.*

In this Pietà, Michelangelo expressed the emotional, human aspect of Mary mourning over the body of her dead son. The figures are realistic yet highly idealized, as revealed in Mary's youthful appearance and her larger scale, which allows Christ's body to gracefully fit upon her lap.

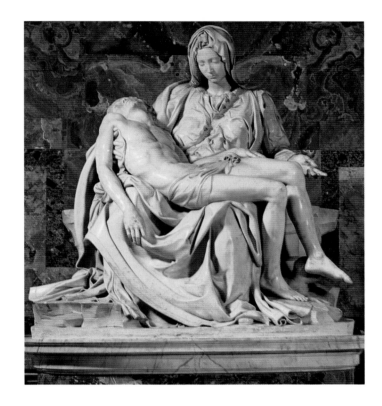

a crowd gathered in St. Peter's. Michelangelo never signed his sculptures, so people immediately began to speculate as to the identity of the artist. According to Vasari, Michelangelo went back later that night and carved his name into the sash that crosses the Madonna's chest.

After Michelangelo was called to Rome in 1505, he worked for a few years on the papal tomb until Julius II temporarily put a halt to the expensive project so that the rebuilding of St. Peter's could begin. While Julius II led the Italian armies against the French who were attacking in Bologna, he ordered Michelangelo to paint the ceiling of the Sistine Chapel. The nine scenes from Genesis took almost four years to complete (1508–12) and the work was done primarily by the artist himself. This was unusual in an age when

ateliers were full of apprentice artists who were expected to perform much of the basic work of their master's commissions.

Michelangelo rejected the new techniques made available by oil pigments, preferring the traditional fresco method of applying pigment directly to wet plaster, forming an unbreakable bond between the two. This is why Michelangelo's frescos are nearly as fresh and alive today as they were the day he painted them, easily cleaned by water and light abrasion. Unfortunately many of Leonardo's paintings, in which he experimented with fragile oils and tinted glazes, have disintegrated under centuries of exposure and restoration.

The nine scenes of the Sistine Ceiling alternate between large and smaller rectangular sections that are supported by pagan sibyls and Hebrew prophets. The ancestors of Christ, as per the Gospel of St. Matthew, are painted in the triangular spandrels and semicircular lunettes above the windows. The architectural plinths between the large sections are an illusion Michelangelo painted on the curving vault.

In order to convey the biblical narratives, Michelangelo used his skill to idealize the essence of each scene into a few key figures and gestures. Like Leonardo, Michelangelo was obsessed with perfect anatomy: for Leonardo it was a statement of a scientific absolute, while Michelangelo believed that an image of perfect beauty could somehow transcend mere physicality by revealing the soul.

Michelangelo finished the entire ceiling just before Julius II's death early in 1513. The Tomb project was once again revived and reduced, as Michelangelo rapidly completed three major works which were to decorate the monument: the sculpture of Moses and two slaves who writhe in bondage—perhaps in memory of his own bondage to the tyrant patron.

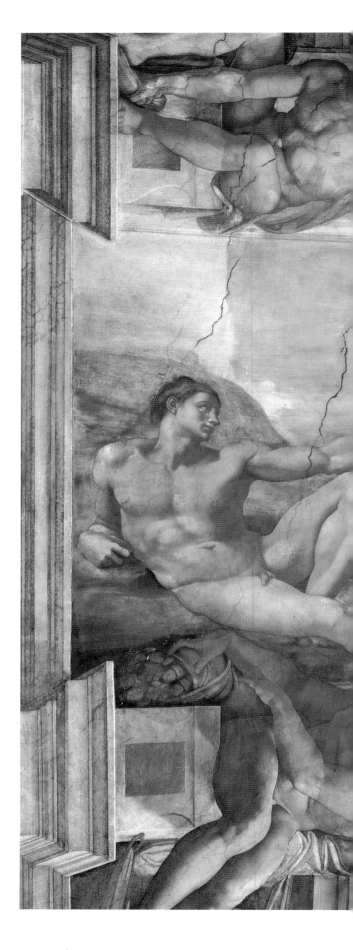

### The Creation of Adam

*MICHELANGELO, 1511. Sistine Chapel, Vatican, Rome.*
This image of God is the perfect Renaissance blend of
realism and symbolism. The all-powerful God brings the
cloak of heaven toward earth where a barely animate
Adam reclines. The moment of creation is concentrated
at the smallest gap separating Adam from the finger of God.

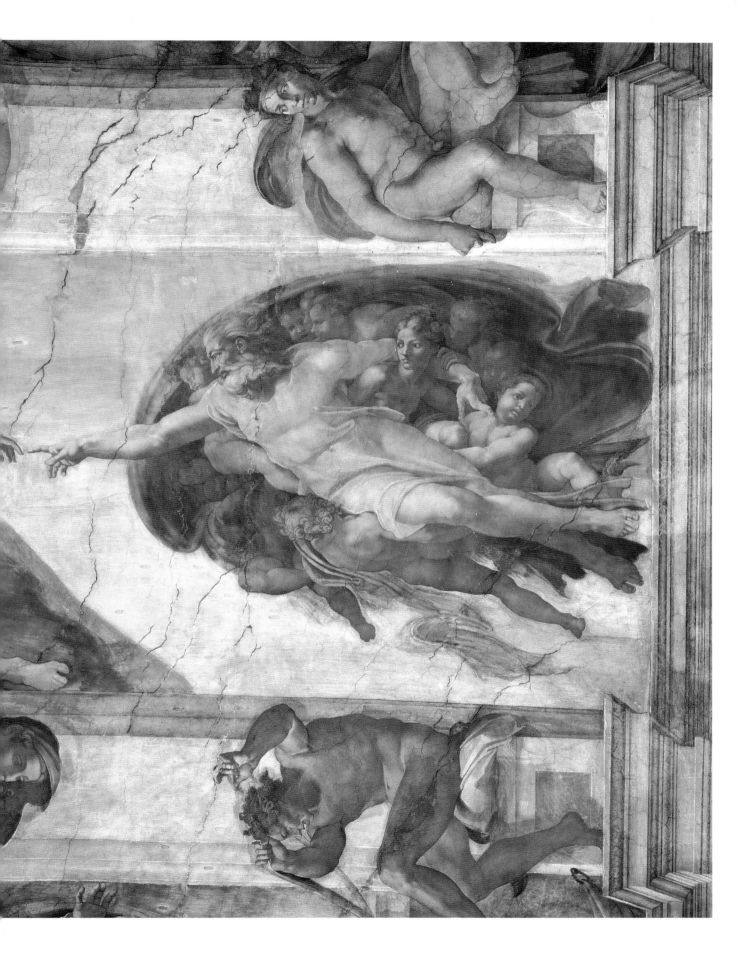

**Design of Elevation for St. Peter's**

*DONATO BRAMANTE, 1506; pen drawing. Gabinetto dei Disegni e Stampe, Florence.* Bramante's centralized church plan was classically perfect, but the Greek cross design did not suit the needs of the liturgy because the altar could only be seen from one aisle.

## BRAMANTE

Bramante (c. 1444–1514) was a mature artist when he arrived in Rome shortly before the election of Pope Julius II. He was commissioned by Ferdinand and Isabella of Spain to design a shrine to be built on the spot of St. Peter's crucifixion, next to the church of San Pietro in Rome.

The circular *Tempietto* (1502–11) was originally intended to be surrounded by a circular courtyard. Bramante designed the structure so that the outer edge of the courtyard was surrounded by a colonnade of widely-spaced columns, each one echoing a column in the Tempietto. In its present location, squeezed into a narrow courtyard, the Tempietto seems more like a sculpture than a building.

When Julius II decided to reconstruct St. Peter's, he hired Bramante in 1506 to draw the designs. The artist lived to see the construction of the four main arches that would eventually support the enormous dome, and he supervised the laying of the foundations for most of the cross and some of the side chapels. He intended for the apse to have three bays, with the huge tomb of St. Peter at the crossing.

As building continued though the decades, the design of the great cathedral was transformed and altered by a succession of inspired architects. The job was eventually completed by Michelangelo, who adapted Bramante's original plans for the exterior and the dome.

### Tempietto

*DONATO BRAMANTE, 1502–11. San Pietro in Montorio, Rome.* Bramante based the design for this tiny structure on the symmetrical plan of the Roman Temple of Vesta. It is one of the key structures in architectural history because of the influence of its centralized design.

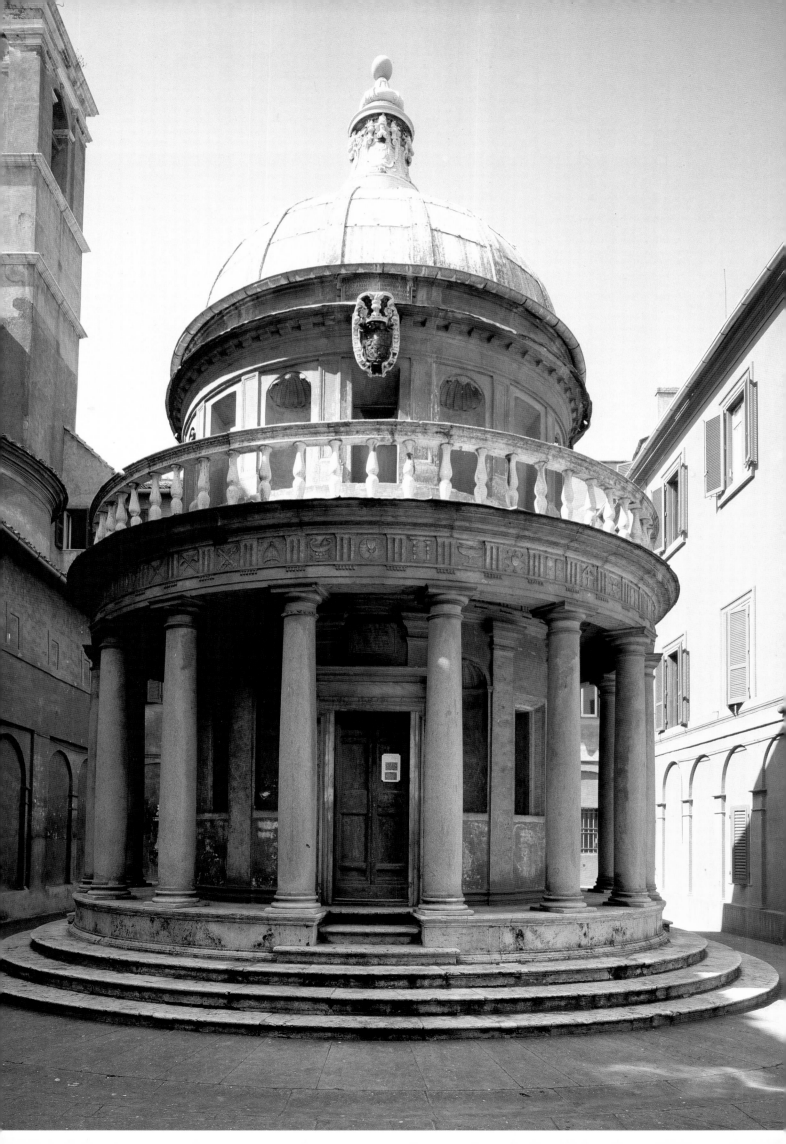

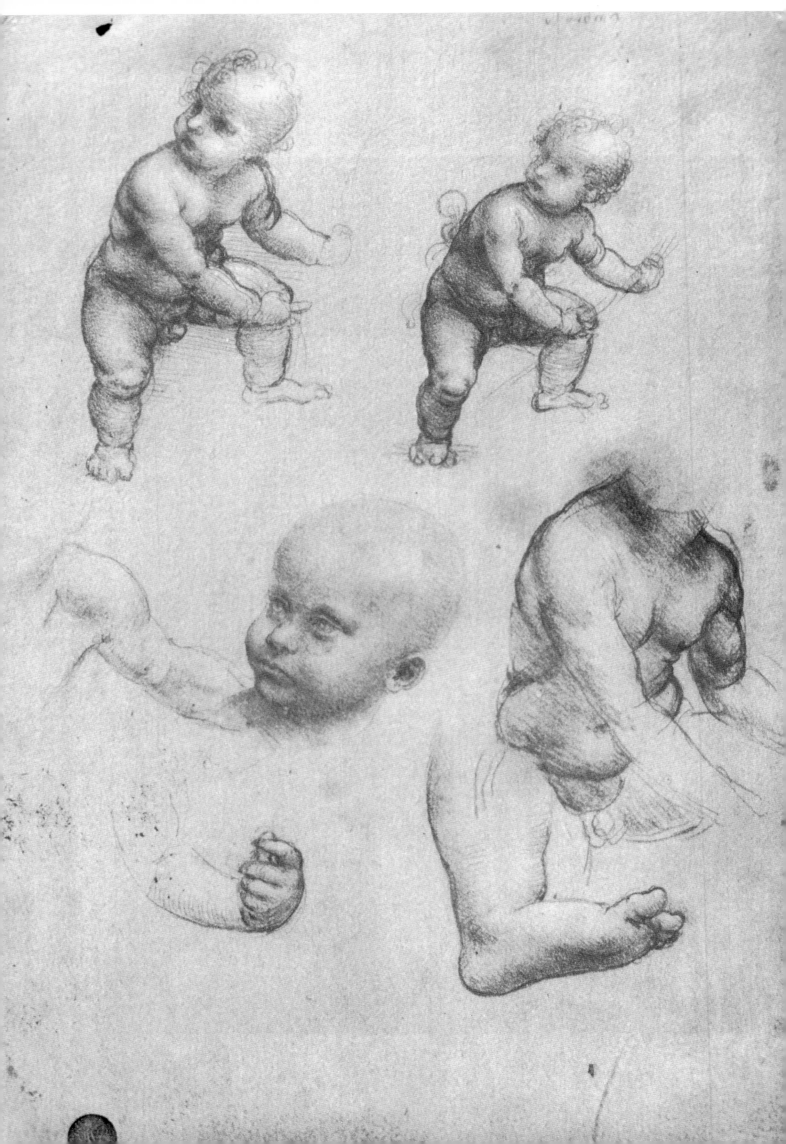

Leonardo's experiments with oil pigments, however, were destined to be a disappointment. While his Madonna panels retain an astonishing depth and clarity despite the fine crackled surface of the glazes, Leonardo's large wall mural of *The Battle of Anghiari* (1503–06) was a failure. This painting for the Palazzo Vecchio was commissioned to commemorate the Florentine victory in 1440 against the Milanese duke Filippo Maria Visconti. Leonardo began work on the mural but, when the pigments began to sag and slide down the wall, he abandoned it in 1506.

Between 1506 and 1557 (when Vasari repainted the wall as part of his series on Grand Duke Cosimo I) thousands of artists viewed Leonardo's partially completed work. Today, this lively composition exists only in Leonardo's original sketches, and in copies made by other artists. *The Battle of Anghiari* was one of Leonardo's last works of art, and for the remaining ten years of his life the artist rarely even sketched (he spent more time on scientific pursuits) as he enjoyed a luxurious life in France under the patronage of King Francis I.

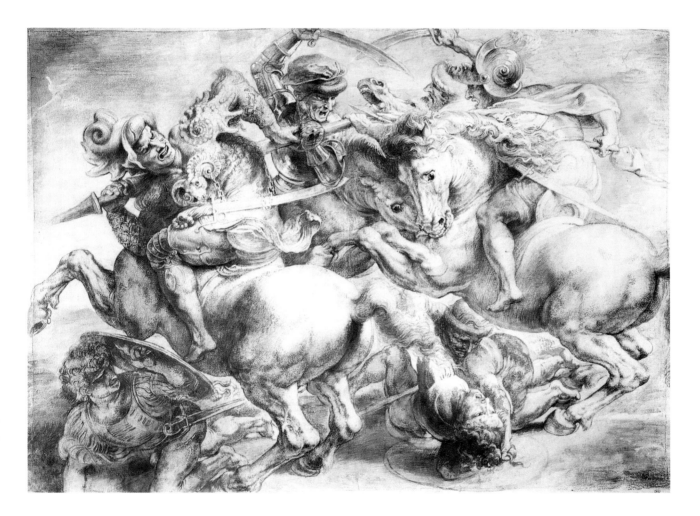

### Drawings of an Infant

*LEONARDO DA VINCI, c. 1510–12. Accademia, Venice.*

In his search for scientific accuracy, Leonardo was not satisfied until he had examined and sketched every part of man from every angle, including this page of drawings of a young child.

### The Battle of Anghiari

*LEONARDO DA VINCI, 1503–06; oil on plaster; copy by Peter Paul Rubens; c. 1615; pen and ink and chalk; 17¾ x 25¼ in. (45 x 64.1 cm). The Louvre, Paris.*

The action of these figures creates an intensity and internal rhythm through the interlocking heads and hoofs and swords. This conveys the sensation of battle rather than its mere appearance.

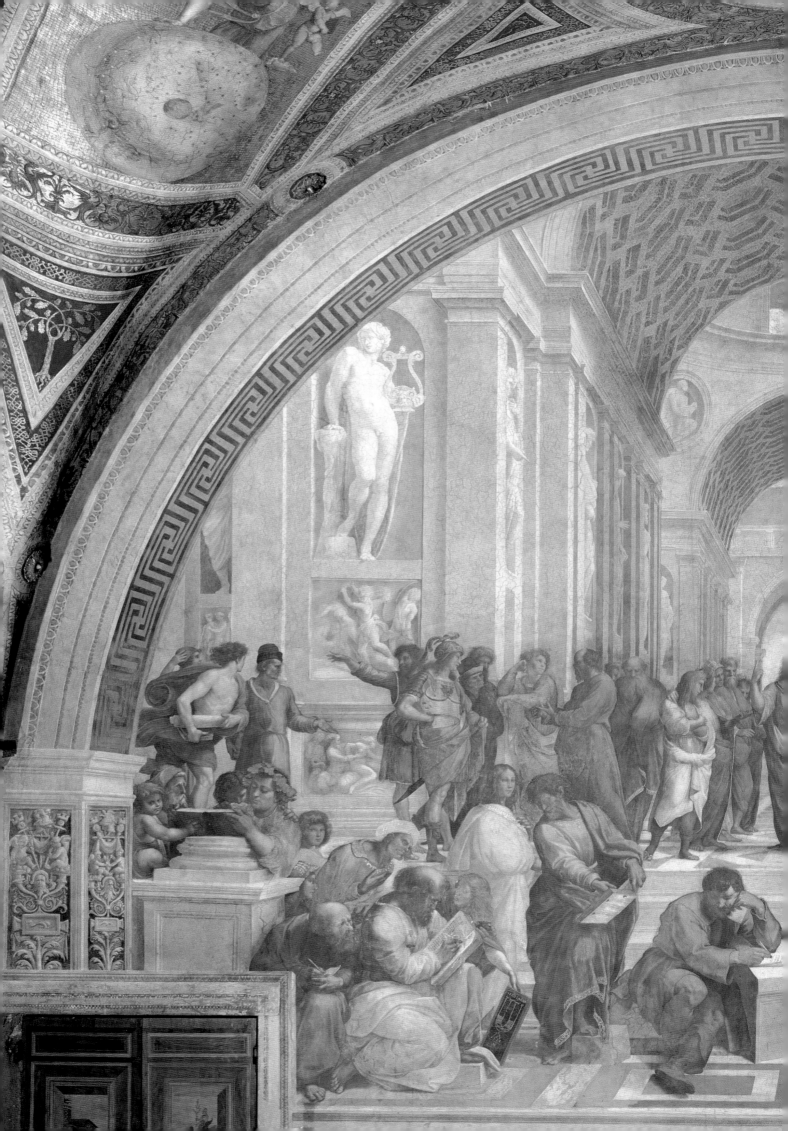

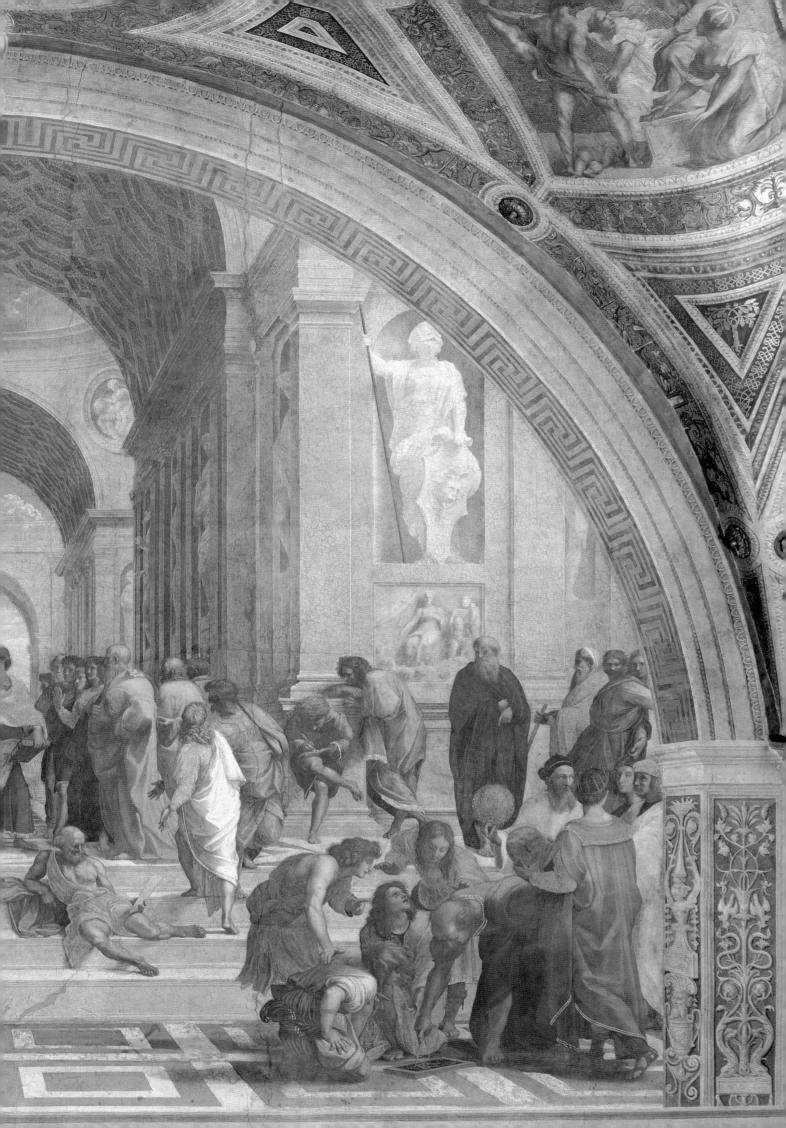

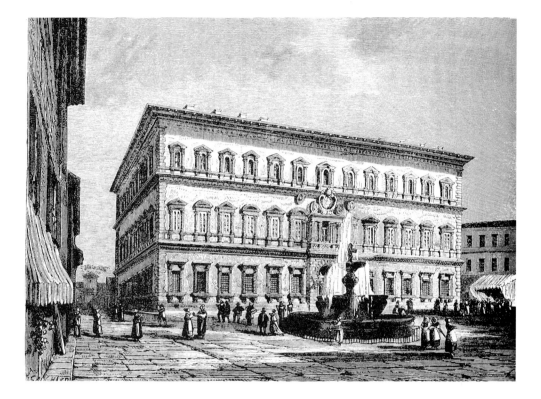

### The Farnese Palace

*ANTONIO SANGALLO, c. 1530–1546. Rome.*

The broad majestic front of the Farnese Palace,
built for Cardinal Farnese, asserts to the public
the royal and papal pomp of this great family.
The original, rather modest palace was enlarged
after the cardinal was elected Pope Paul III in 1534.

### Galatea

*RAPHAEL, 1513; fresco. Farnese Palace, Rome.*

Raphael painted Galatea as his ideal of womanly
perfection, taking the best features from a
number of actual models. She is encircled by
figures while her body twists into a figure eight,
creating a balanced yet dynamic composition.

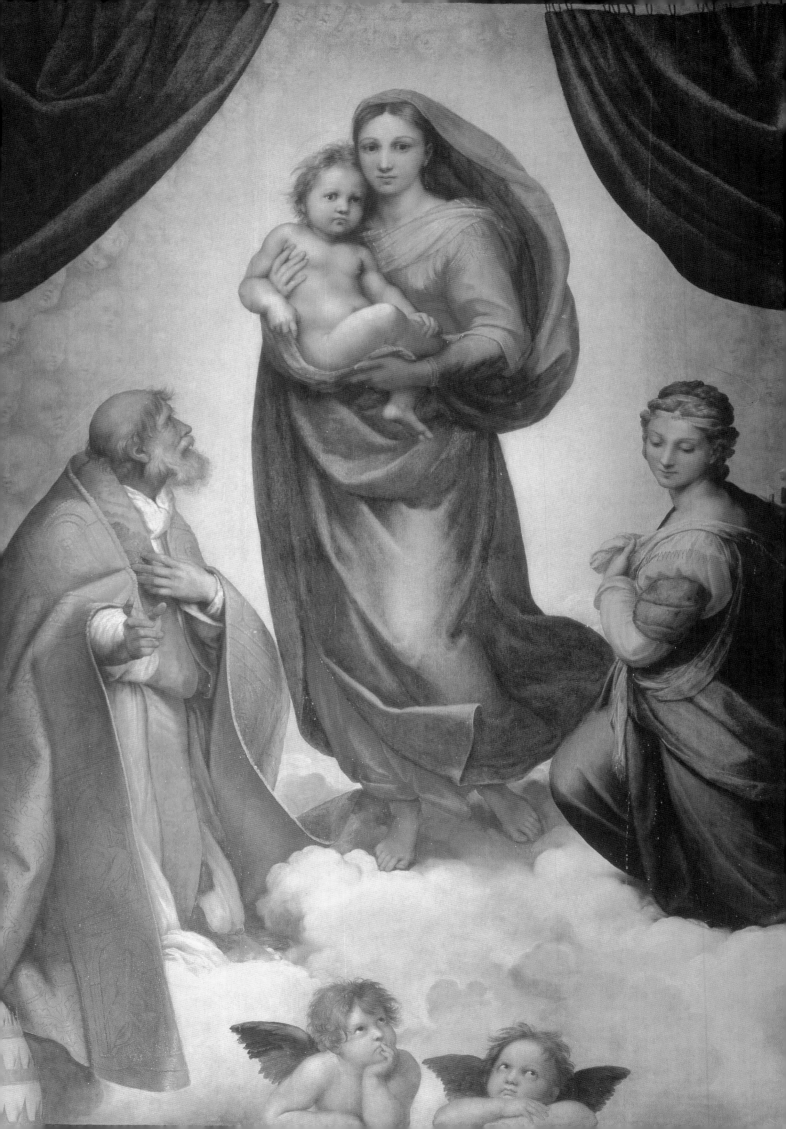

## Vision of St. Bernard

*FRA BARTOLOMMEO, 1504–07; panel;*
*7 ft. x 7 ft.¼ in. (213.3 x 213.9 cm).*
*Uffizi Gallery, Florence.*

Raphael's debt to Fra Bartolommeo can be seen in the monk's idealized realism, particularly in his image of a floating Madonna, the first in a long line of High Renaissance Madonnas that are symbolically raised above the other figures.

## Sistine Madonna

*RAPHAEL, 1513; oil on canvas; 8 ft. 8½ in. x 6 ft. 5 in*
*(265.4 x 195.5 cm). Gemaldegalerie, Dresden.*

Raphael painted this Madonna to be hung over the bier of Pope Julius II upon his death. The painting is grounded by the two putti at the bottom, which have been reproduced since on everything from greeting cards to wall stencils.

## Perseus Liberating Andromeda

*PIERO DI COSIMO, c. 1510; panel; 25³/₄ x 72¹/₄ in. (65.4 x 183.5 cm). Uffizi Gallery, Florence.*
Piero di Cosimo's clean, simple style was best employed in natural settings. His lively animals are reassuringly familiar and lifelike, even when he depicts fantastical monsters.

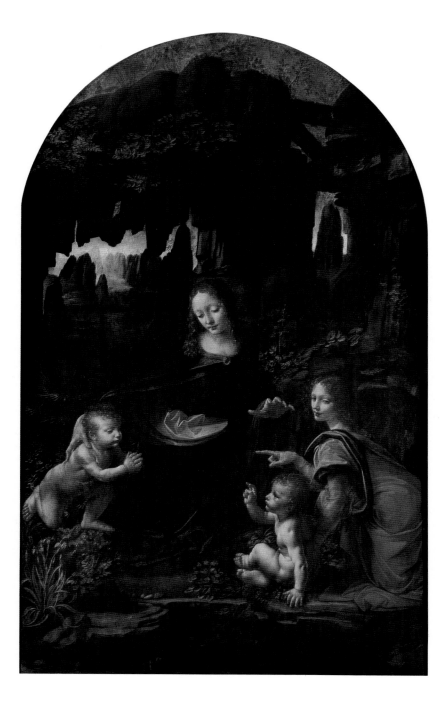

## Virgin of the Rocks

*LEONARDO DA VINCI, c. 1485; oil on wood; 6 ft. 3 in. x 3 ft. 7 in. (190.5 x 109.5 cm). The Louvre, Paris.*

The landscape is fantastical in its dramatic effect, yet Leonardo carefully included authentic
geological details which he had observed in his travels as well as maintaining strict botanical accuracy.

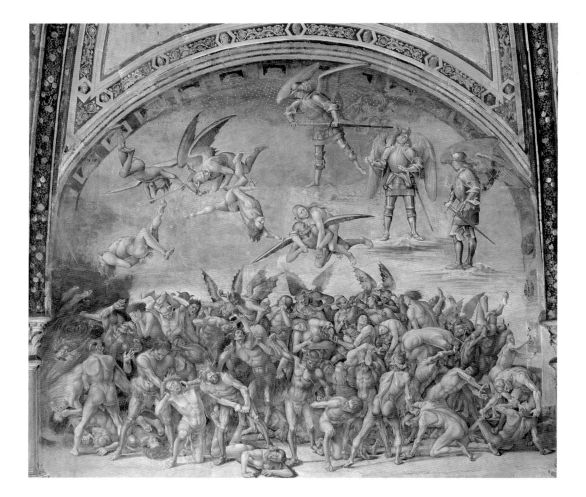

## The Damned Cast into Hell

*LUCA SIGNORELLI, 1499–1504; fresco.*
*S. Brixio Chapel, Cathedral, Orvieto.*

In an attempt at the ultimate realism, Signorelli's figures turn and appeal to the viewer for help. The demons are shown in parti-colors, like the uniforms of German soldiers who would eventually be successful in invading Italy and sacking Rome.

## Santa Maria della Consolanzione

*Unknown architect, 1508. Todi.*

The architect of this church is unknown but the design could only have come from someone with a mastery of classical art. This is one of the few centralized churches that was actually built during the Renaissance.

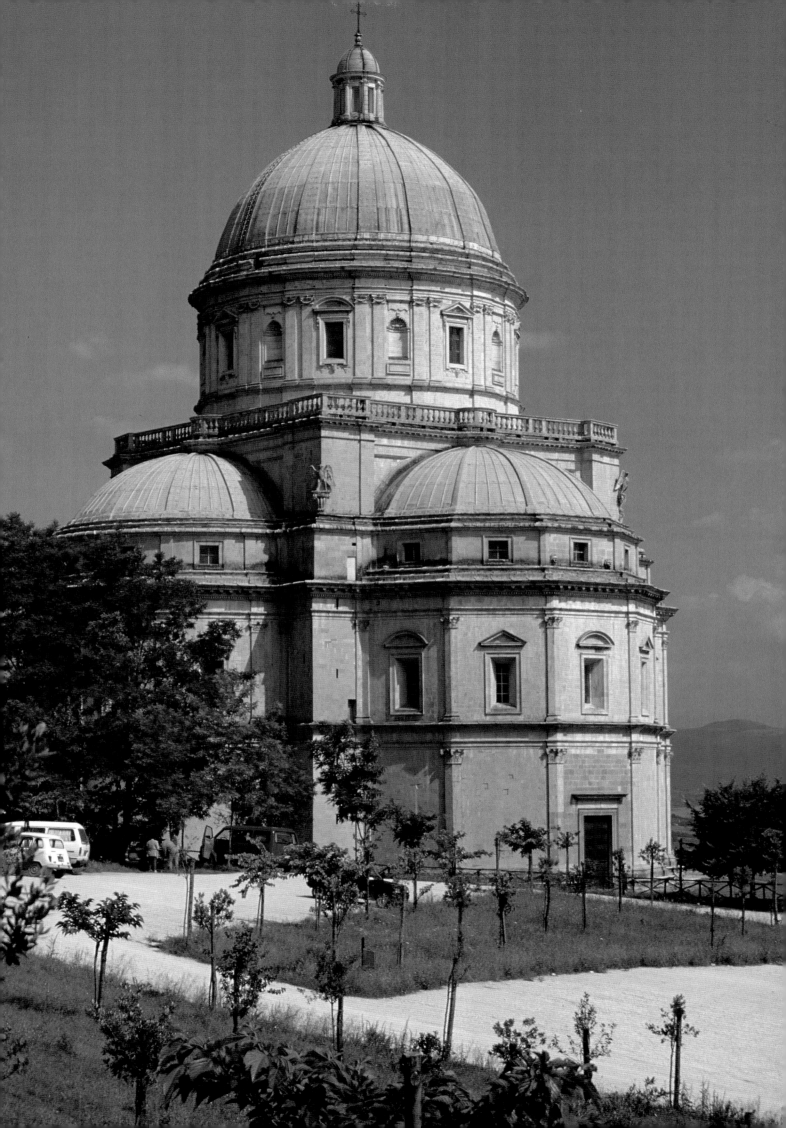

## Madonna of the Long Neck

*Francesco Parmigianino,
1534–40; panel; 85 x 52 in.
(215.9 x 132 cm).
Uffizi Gallery, Florence.*
By manipulating the
proportions and elon-
gating the Madonna's
neck, Parmigianino
has created an impres-
sion of exaggerated
refinement. The unusually
large size of the child
sprawling across Mary's
lap deliberately evokes
parallels with the Pietà.

# Mannerism

Once the classical models had been thoroughly mastered and embellished, artists began to break the old rules. The correct proportions of the human body could be altered for specific effects—the eyes made larger or the neck longer as in Parmigianino's *Madonna of the Long Neck* (1534–40). The constraints of linear perspective could also be set aside in order to attain a more dramatic result. Mannerism represents aspects of High Renaissance style taken to their limits.

Michelangelo was such a creative genius that many of the Mannerist experiments can be credited to the inspiration of his work. His philosophy of pure creativity naturally prompted him to explore art simply for "art's sake." This was a natural step taken once Renaissance artists began to be acknowledged as individual creators. They stretched customary artistic boundaries based on their own inclinations, defending their actions with the Delphic mandate "know thyself."

Michelangelo had more reason than most artists to wish to be free of the contradictory demands of others. He had yet another disappointment after three years of working on the plans for the façade of the Church of San Lorenzo. He had barely quarried enough marble for the statues that were intended to decorate the niches when his contract was canceled. In 1520, after the death of Lorenzo, Michelangelo was pulled off the

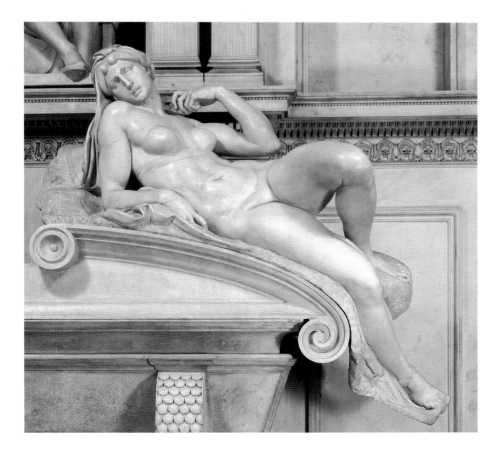

**Dawn**

*MICHELANGELO, 1524–34; marble.*

*Tomb of Lorenzo de' Medici, Medici Chapel, S. Lorenzo, Florence.*

Nude figures representing Night and Day, Dawn and Twilight decorate the sarcophagi. These figures were probably intended to symbolize the perpetual celebration of Mass and the prayers that would be said for the salvation of the dukes' souls.

façade so he could create the Medici Chapel in S. Lorenzo which would house the tombs for Lorenzo the Magnificent and Guiliano de' Medici.

While working on the statues for the Medici tomb, Michelangelo also began designing the new library for San Lorenzo, in which to house the enormous Medici collection. For almost thirty-five years, Michelangelo worked on the designs for the Laurentian Library, including an unusually shaped, triangular rare-book room and the desks that were to line the long reading room where scholars would sit to study the manuscripts. In 1557 Michelangelo submitted his last model for the staircase in the Entrance Hall leading up to the library. But he never saw the finished Laurentian Library that was eventually built on top of the monastic buildings connected with San Lorenzo.

Michelangelo's final design for the imposing staircase in the Entrance Hall is a startling blend of sculptural and architectural elements. The curving center steps give motion to the heavy mass that is strikingly counter-echoed by the scroll buttresses. Even the columns are more like statues than architectural supports since they are merely set in the wall, ornamented by decorative scrolls underneath.

## THE EARLY MANNERISTS

The term "Mannerism" was derived from *mano*, the Italian word for "hand." Manual dexterity and technical skill were prized over realism, and artists vied with each other for unique effects.

Critics persisted in considering the Mannerist style a decline from the ideals of the High Renaissance. This derogatory view among art connoisseurs lasted well into the modern age, until the Impressionists' experiments with visual effect led to concerns over pure technique associated with Cubism.

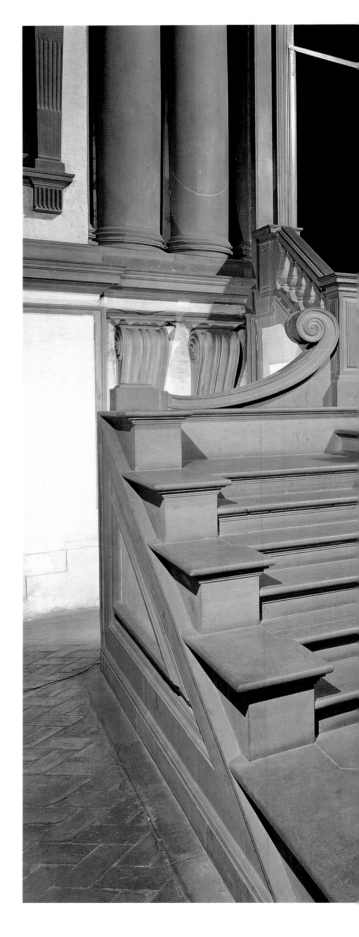

### The Entrance Hall of the Laurentian Library

*MICHELANGELO, 1524–34; staircase completed 1559.*

*Laurentian Library, S. Lorenzo, Florence.*

The curving, fluid steps of Michelangelo's staircase have no precedent in classical or Byzantine architecture.

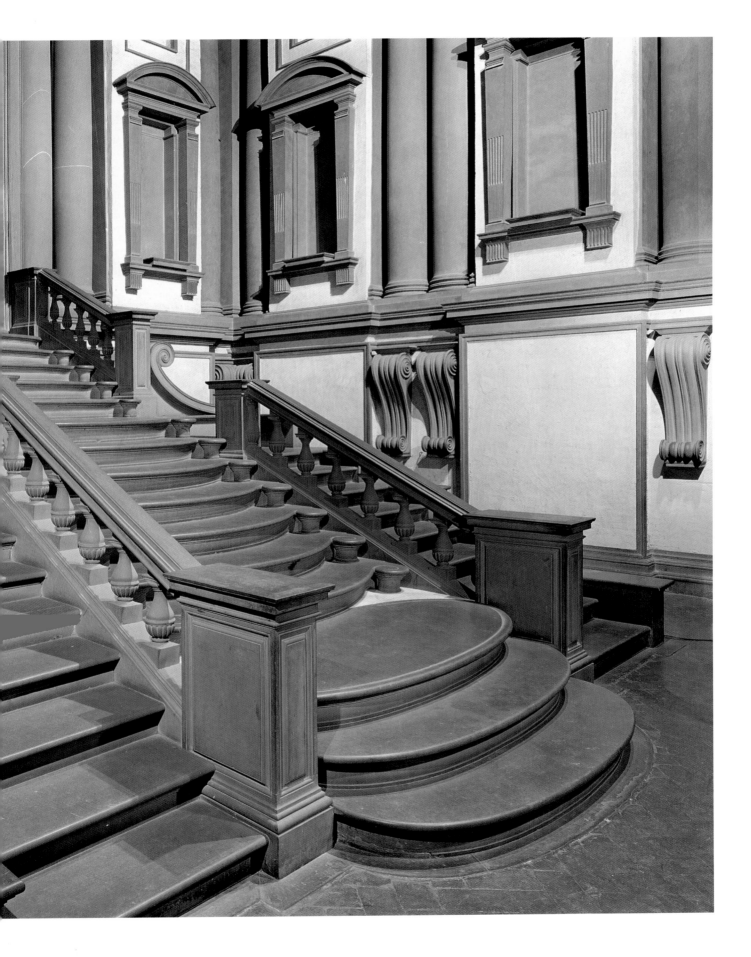

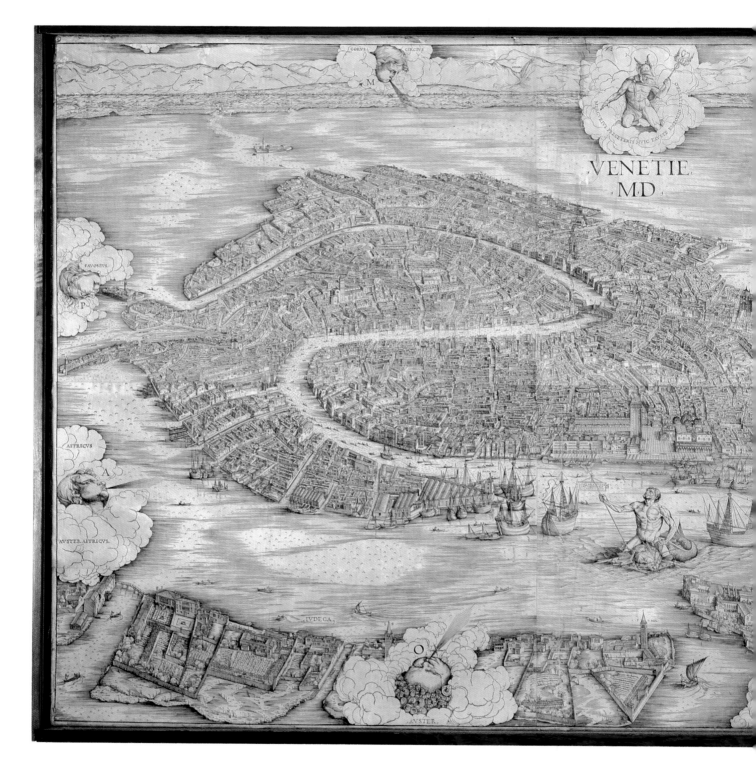

## Map of Venice

*JACOPO DE BARBARI, c. 1600. Ufficio Direzione Palazzo Ducale, Venice.*

The government of Venice consisted of an oligarchy drawn from two hundred of the most notable families which successfully ruled the only overseas empire of the Italian states.

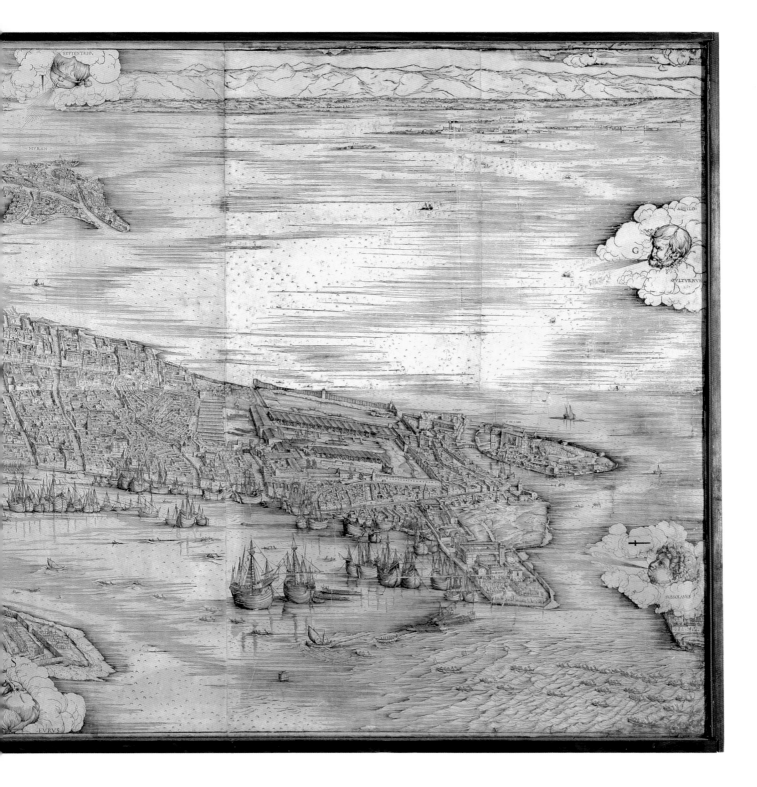

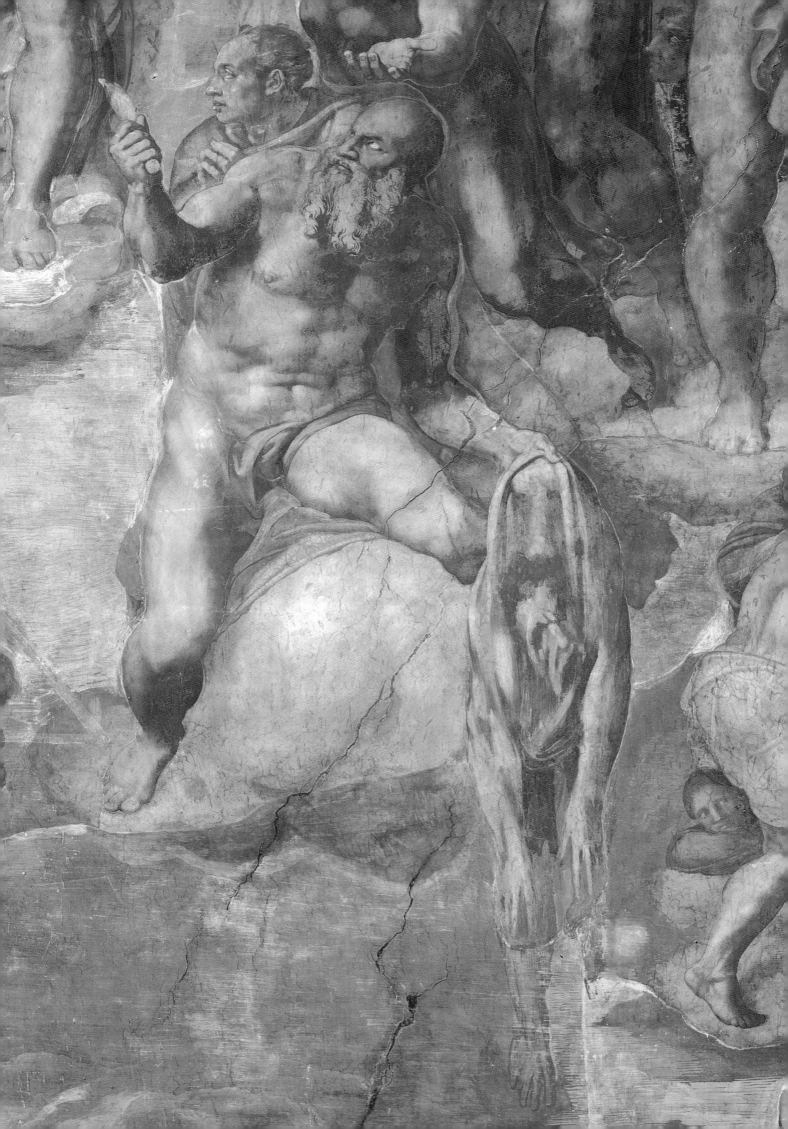

most contemporary artists, Michelangelo resisted working for the popes and longed for a return of the creativity he had experienced during his early career in Florence.

Vasari, on the other hand, was determined to please his ecclesiastical patrons with ever-increasing refinements of established, tasteful forms. Indeed, the term "maniera" was first used derogatorily by Venetian artists to describe Vasari's tendency to paint faces and figures alike. But Vasari was quite prosperous, employing dozens of assistants who were amazingly prolific.

The walls of Rome and Florence were covered by Vasari's trademark frescoes—elaborate compositions of patterned lines and gestures that were enhanced for purely decorative effect. Vasari painted *Perseus and Andromeda* for the Studiolo, a room in the Palazzo Vecchio that served as the scientific study for Francesco I de' Medici. The Florentine ruler experimented with alchemy and studied minerals and geological samples. Over thirty paintings and sculpture were commissioned from the best artists of the day to decorate his study.

Vasari also was considered to be an accomplished architect, and his crowning triumph was the Uffizi in Florence, commissioned by Cosimo I in 1560 and not completed until 1580, six years after Vasari's death. The Uffizi is actually a series of buildings, including a house and the Church of San Piero Scheraggio, which were taken over to house the governmental records and offices for the Dukes of Florence. Vasari constructed a unifying façade for the front of the existing buildings, and the result is a claustrophobic, narrow plaza lined with colonnades. At the far narrow end, a small centralized arch allows a beacon of light to enter.

### The Last Judgment

*MICHELANGELO, detail; 1536–41; fresco. Sistine Chapel, Vatican, Rome.*
Among the Apostles who gather around Christ is the figure of St. Bartholomew, the saint who was flayed alive because of his faith. The empty skin bears the distorted face of Michelangelo, an anguished expression of the artist's endless spiritual and artistic struggles.

### Perseus and Andromeda

*GIORGIO VASARI, 1570–72; oil on canvas; 45½ x 34 in. (115.5 x 86.3 cm). Studiolo, Palazzo Vecchio, Florence.*
According to mythology, coral was created from the blood of a dragon who was about to attack Andromeda. When Perseus plunged his sword into the dragon, both its body and blood were turned to stone.

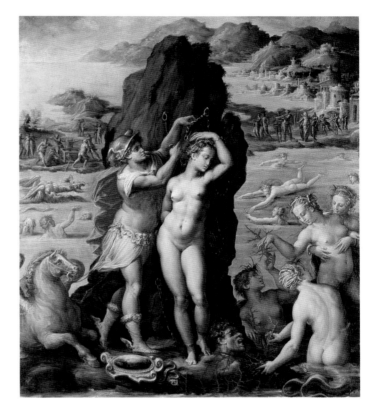

## The Counter-Reformation

During the sixteenth century, the Church was concerned primarily with countering the attacks made by the Reform movement. Bitter battles in print and endless negotiations were undertaken to try to reconcile the Reformation with the Catholic tradition. As the Church underwent reform, the Counter-Reformation emerged: a movement that emphasized the holy nature of the sacraments that had been rejected by the Protestants. New monastic orders were formed, such as the Jesuits, whose intention was to defend the faith by word of mouth. There was an increased demand for elaborate altars, relic-shrines, and pictures of the saints and their miraculous deeds.

In 1522 a Dutchman, Adrian VI, was elected Pope (the last non-Italian pope until Pope John Paul II, 1978). Though he only served for two years, this pious northern pope had a huge impact on Roman society. He evicted the entire papal entourage that had established itself around the previous Medici popes—Julius II and Leo X—and also put a stop to all artistic projects at the Vatican, leaving many works uncompleted. Pope Adrian VI was so unpopular with the Italians that his early death is generally believed to have been caused by poison. Pope Clement VII (formerly Giulio de' Medici) was then elected, in 1523, once more putting the Medici's in control of the Vatican.

Rome continued to be the center of power and money during the sixteenth century, but Adrian VI's abrupt dismantling of the papal artist community was not so easily overcome. Florence, too, was becoming culturally stagnant, with much of the commerce under the iron grip of the Medici.

In addition, the Council of Trent (1545–63) set standards of propriety, which can be seen even in the masterpiece of the day, Michelangelo's *The Last Judgment*, in which the nudes are modestly draped with loincloths.

An artist known as Correggio (his real name was Antonio Allegri) also managed, like Michelangelo, to successfully combine elements of the High Renaissance with that of Mannerism. But where Michelangelo's work displays a tension between the natural and the dramatic extremes in presentation, Correggio's figures are soft and yielding, combining sensual textures and surfaces with perfect form. Yet the Church did not censure the nudity in Correggio's paintings because of the sweet purity of faith that infused every work.

### Jupiter and Io

*CORREGGIO, early 1530s; oil on canvas; 64½ x 28 in.*
*(163.8 x 71.1 cm). Kunsthistorisches Museum, Vienna.*
Correggio painted Io in religious ecstasy at the embrace
of Jupiter (in the guise of a dark cloud). Such an erotic
rendering was extraordinarily daring, but Correggio's
fearless portrayal of the myth stood unchallenged.

## VENICE

With all the political turmoil in Rome and Florence, the cultural center of the Renaissance shifted to Venice during the mid-sixteenth century. Artists such as Titian, Giorgione, Tintoretto, and Veronese took advantage of the eclectic atmosphere of the great sea-faring empire. Venice ruled not only its watery city but a great deal of mainland Italy as well, all in service to the merchant fleets which brought back exotic goods and innovations.

Venice was active, prosperous, and relatively free, unlike the Florentine republic which was under stern Medici rule and therefore captive to the papacy in Rome. Instead of great court commissions, there emerged in Venice works like those of Giorgione, whose brief career is notable for an abundance of moody landscapes. His best-known work is a small painting called *The Tempest* (1505–10). Nothing is known about the identity of the nude woman and the child she is nursing, or why the soldier is standing guard. Indeed, in the earliest reference to the painting, in 1530, Marcantonio Michiel called the woman a "gypsy" and mistakenly attributed the painting to Zorzi da Castelfranco.

When much later the painting was examined by X-ray, it was discovered that under the soldier, Giorgione had originally painted a nude woman. This indicates that the artist had no guiding narrative in mind when he conceived the landscape. This was a typically Mannerist tendency, subverting the ideals of the High Renaissance which called for nobility of subject as well as form.

**The Tempest**

*GIORGIONE, 1505–10;*

*oil on canvas; 30¼ x 28¾ in.*

*(76.8 x 73 cm). Accademia, Venice.*

The woman seems to be at the mercy of the wild environment, crouching under lowering sky in the weed-choked ruins. The scene seems so utterly believable that generations of critics have tried to find the literary subject that was Giorgione's inspiration.

## Titian

The next Venetian artist to take the lead after Giorgione was his young assistant Titian (c. 1488–1576). Titian's work exemplified Mannerist developments in the nude figure; he focused on atmosphere and sensuality rather than correctness of anatomy.

His brushwork was singularly notable. Rather than record every detail, Titian used color and light to suggest the form and mood of the subject. The painter's preference for layer upon layer of glazes was well known, and these glazes lend a certain depth and inner light to his scenes. His *Venus of Urbino* (1538) was the

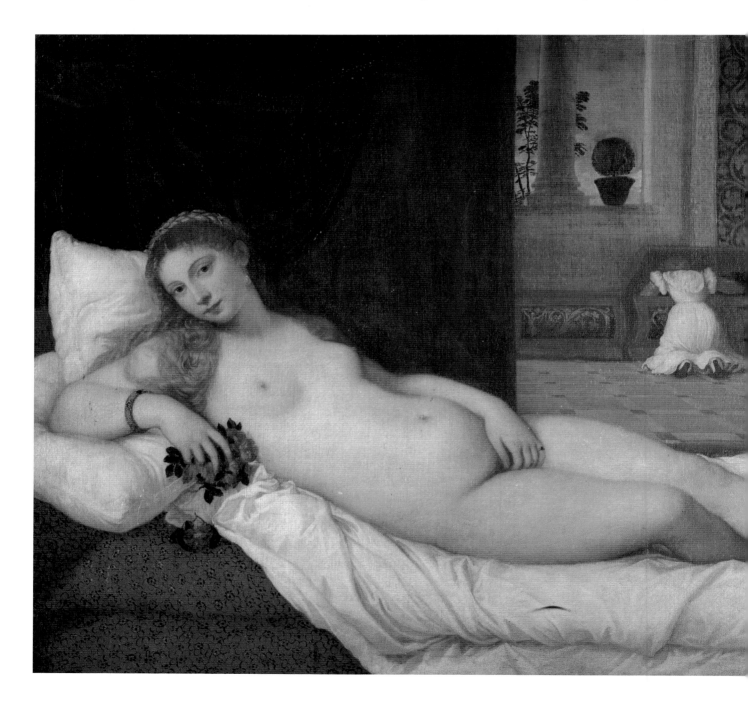

## Sleeping Venus

*GIORGIONE, c. 1510; oil on canvas;*
*42³⁄₄ x 69 in. (108.5 x 175.2 cm).*
*State Art Gallery, Dresden.*
This was Giorgione's last
painting, finished by Titian
after his death. The composition
is pure Giorgione, set in the
Venetian landscape with a glint
of the sea in the distance.
The curves of Venus's body
echo the hills that enfold her.

## Venus of Urbino

*TITIAN, 1538; 47 x 65 in.*
*(119.3 x 165.1 cm).*
*Uffizi Gallery, Florence.*
Titian copied the pose of
Giorgione's *Venus* but not his
mythological interpretation.
Instead, Titian presented the
goddess as the Renaissance
allegory for romantic love.

earliest of a long series of his reclining female nudes. A comparison with Giorgione's *Sleeping Venus* (1510) reveals the same pose, except that Titian's Venus is awake and directly confronting the viewer in brash Mannerist boldness.

However, there is a question as to whether the woman is in fact a representation of Venus because of the lack of mythological references. In the background, a servant rummages through a chest at the order of a lady's maid. Titian's focus is on the abundancy of rich textiles, and seems to suggest that the nude woman is a mistress to a prosperous Venetian rather than the fertility goddess whom Giorgione so lovingly depicted in natural surroundings.

## Tintoretto

If Giorgione would have been appalled by his assistant's interpretation of his Venus, Titian himself was brought into direct competition with Tintoretto (1518–94), an artist who was once *his* own student. The meticulous Titian dismissed Tintoretto's ability the first time he saw one of the boy's rough and dynamic sketches, kicking the young painter out of his atelier.

Tintoretto never seemed to hold a grudge against Titian, and he persisted in calling the older artist his master. Tintoretto competed directly with Titian for commissions, and even cut his own bids in order to get work. His rapid style revealed a raw enthusiasm for painting and it gave his work an edge that the more meticulous artists lacked. Tintoretto's colors, though, were never as brilliant as most Mannerist artists because of his tendency to quickly under-paint the basic structure in dark tones of green, brown, or gray.

Tintoretto was able to use this darkness to notable effect in one of his last works, *The Last Supper*, com-

### The Last Supper

*TINTORETTO, 1592–94; oil on canvas; 12 ft. x 18 ft. 8 in.*

*(365.7 x 568.9 cm). Chancel, S. Giorgio Maggiore, Venice.*

Tintoretto distinguished the spiritual act of communion from the secular environment by placing the table at an angle, separating the Apostles from the servants who are preparing the meal.

pleted in 1594. The highlights that edge the figures—casting an otherworldly ambiance—lends the painting a monumentality despite its realistic, humble setting. Even the angels seem perfectly reasonable as they float in the rays cast by the lamp.

Tintoretto often stages the view from an unexpected angle, but unlike Pontormo he never lets his busy compositions violate the bounds of nature. In this way, his work is similar to Michelangelo's: both artists placed their figures in expressive poses that served the narrative of the subject.

## BRONZINO

Bronzino (1503–72) was undoubtedly the best of the late sixteenth century artists. He was the favorite pupil of Pontormo, who painted Bronzino's portrait as a small boy in a cloak seated on the steps, in *Joseph in Egypt*.

Bronzino's style was much more restrained than Pontormo's elaboration of form and figure. His sur-

faces invariably shine with the glint of satin, porcelain, metal, or polished marble. The attention to the sharp edges of contrast between objects creates a rather stylized effect in his compositions.

Bronzino did endless portraits for the Medici family and the court, and the artist could be accused of the same repetition in facial style that applied to Vasari. In Bronzino's work, however, the idealized masks of his subjects seem to reflect the rigid rule of Cosimo I (duke of Florence and later Tuscany). This restraint can be seen in the artist's *Lucrezia Panciatichi* (c. 1540), which adhered to the traditional usage of clothing to delineate the power and wealth of rulers and courtiers. In most European countries, laws dictated what kinds of materials, colors, and furs could be worn by each rank in order to keep the lower classes from mimicking their betters.

## Post-Renaissance Art

The achievements of the High Renaissance remained authoritative for three centuries as artists interpreted, developed, and modified the classical traditions. Baroque painting was a mix of formal applications combined for dramatic appeal, while the naturalists (principally the Spanish and Dutch schools) rejected systems of proportion and relied on painting exactly what the eye could observe. The Renaissance art of allegory exploded: walls, ceilings, entire rooms, and even buildings were decorated with frescoes celebrating the accomplishments and power of various popes, princes, and nobles, albeit cloaked in mysterious and sometimes incomprehensible allusions.

The Bolognese Academy (founded around the turn of the seventeenth century) was the first significant institution to teach an academic philosophy of art based on the Renaissance techniques of studying anatomy and drawing from life. This style renounced the affectations of Mannerism in favor of a vigorous interpretation of nature and an interest in human themes and emotions. The diverse artistic techniques

**Lucrezia Panciatichi**

*Agnolo Bronzino, c. 1540; oil on canvas. Uffizi Gallery, Florence.*
Lucrezia Panciatichi wears red, a favorite color in Renaissance Italy, and she is as conspicuously modern in her jewels as in her dress.

developed during the Renaissance allowed each major sculptor and painter to replicate or manipulate reality at will.

The Renaissance was truly the beginning of the era of modern man, when scholars, philosophers, and artists began the as yet ongoing quest toward understanding reality through systems of observation. Descartes summed up the power of the individual when the philosopher asserted, "I think, therefore I am." As a result of Renaissance explorations, Western civilization moved with energy and expectation into the age of science.

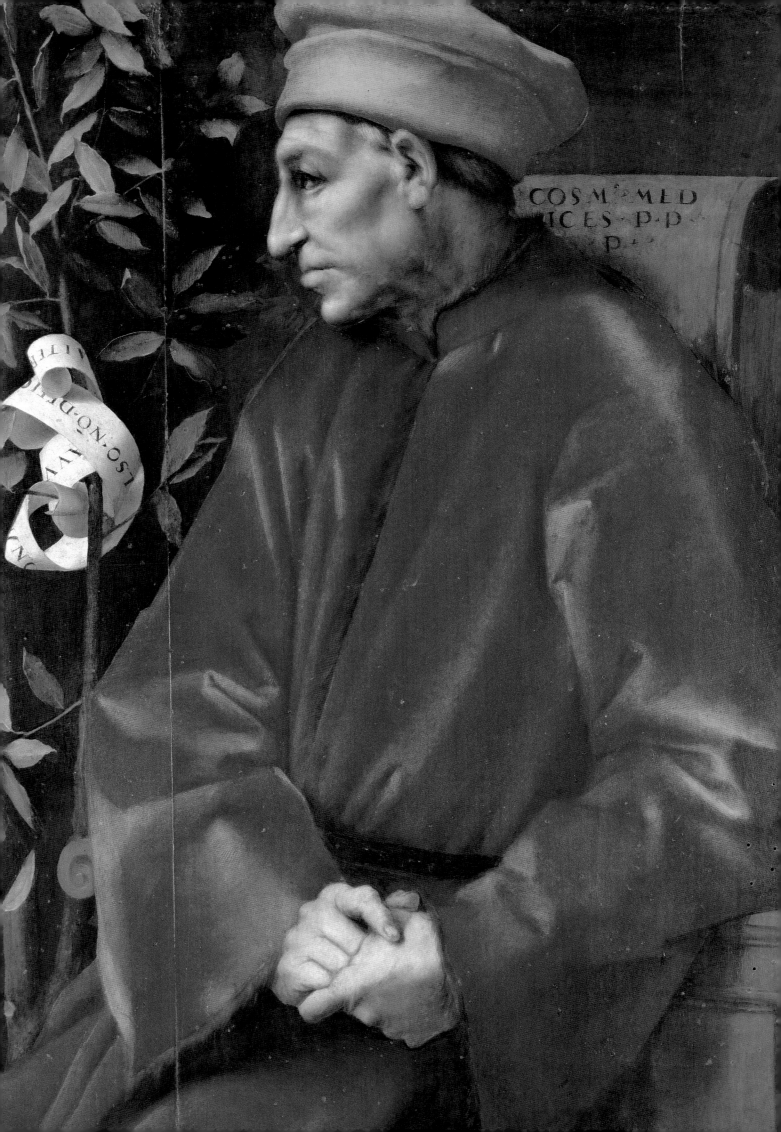

COSM MED
ICES · P · P ·
P ·

### The Bacchanal of the Andrians

*TITIAN, c. 1522–23;*
*oil on canvas; 69 x 76 in.*
*(175.2 x 193 cm).*
*Prado, Madrid.*
Titian modeled the
reclining nude in the
lower left-hand corner
after the *Sleeping Ariadne*,
an ancient Roman statue
that was imitated often
by Renaissance artists.

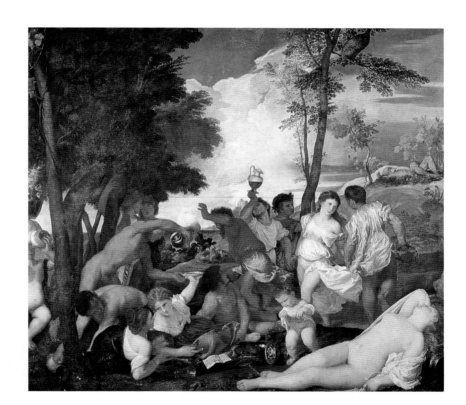

## Cosimo de' Medici, the Elder

*JACOPO PONTORMO, c. 1518; oil on wood; 45 x 25⅓ in. (87 x 65 cm). Uffizi Gallery, Florence.*
As the teacher of Agnolo Bronzino and a contemporary of Rosso Fiorentino,
Pontormo was one of the primary creators of the early Mannerist style. Aristocrats
loved his sensuous, vibrant portraits which were typical of sixteenth-century Italy.

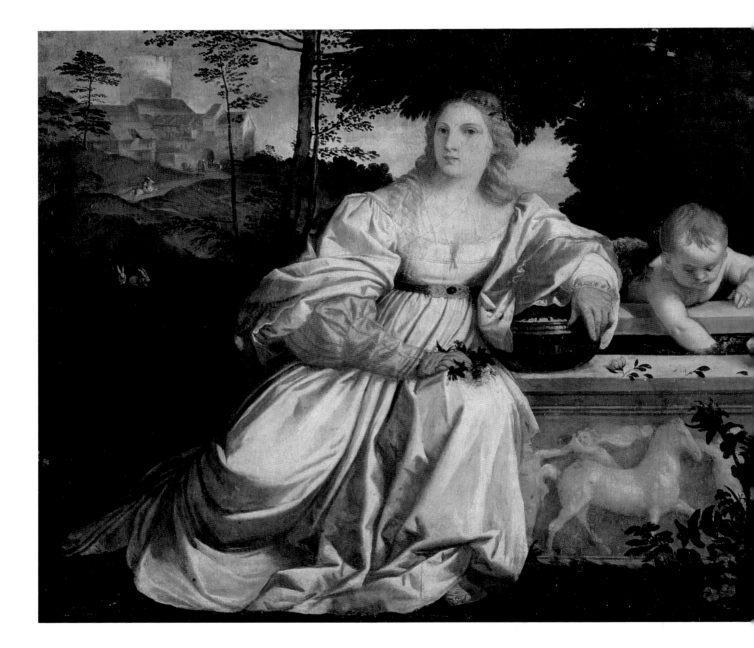

### Sacred and Profane Love

*TITIAN, 1515; oil on canvas; 3 ft. 11 in. x 9 ft. 2 in. (119.3 x 279.4 cm). Borghese Gallery, Rome.*
Some scholars suggest that this was intended to be a Neo-Platonic image
of the Terrestrial and Celestial Venuses. Others claim it is the wedding
portrait of a Venetian nobleman's bride visiting the Fountain of Venus.

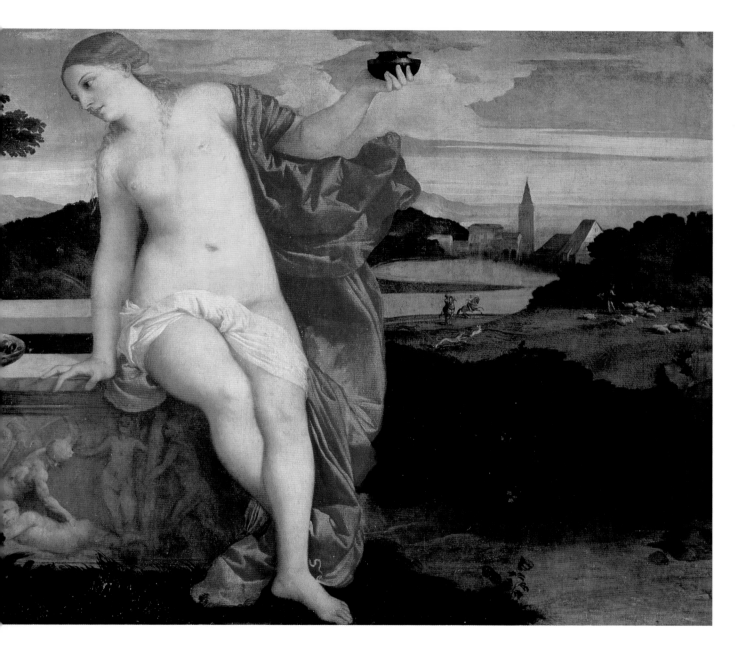

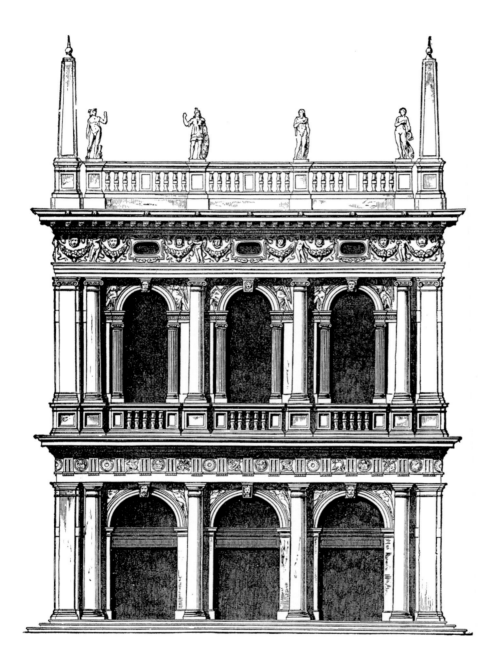

**La Zecca (Mint) and
Library of S. Marco**

*JACOPO SANSOVINO,
begun 1535. S. Marco, Venice.*
Shown here are two views
of the Library of S. Marco—
one an early engraving, the
other a modern photograph.
No walls appear on these
structures, only clusters of
columns and piers. Even the
upper contour of the library
is broken into verticals by
the balustrade, statues, and
the obelisks at the corners.

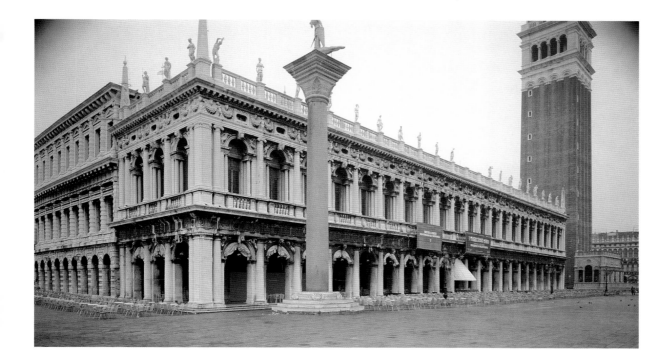

*FOLLOWING PAGE:*

**Vision of St. John the Evangelist**

*CORREGGIO, 1520–24; fresco. Veduta della Cupola, Duomo, Parma.*

With the mastery of realism came the ability to create illusions
transcending the flat barrier of canvas, plaster, and wood.
Looking up into Correggio's dome, the viewer apparently is able
to see through the spiral of clouds and angels into Heaven itself.

**Room in the
Borghese Palace, Rome**

An early engraving of the interior of the

magnificent Borghese Palace in Rome offers

a window on aristocratic life in past centuries.

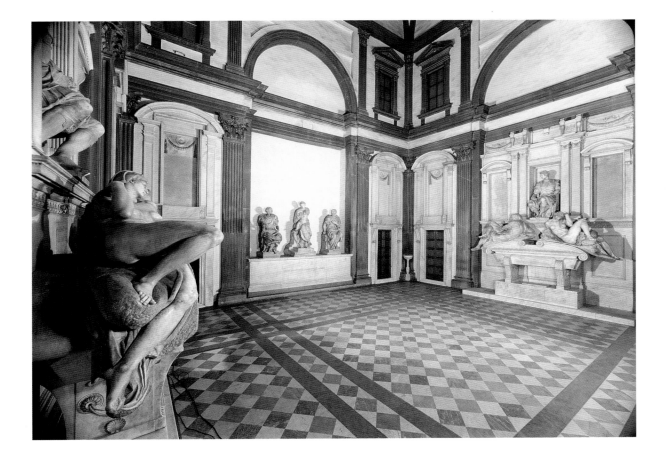

## The Medici Chapel

*MICHELANGELO, 1519–34. S. Lorenzo, Florence.*

After rapidly designing the chapel and tombs, Michelangelo spent the next tumultuous

decade enduring the Sack of Rome (1527) and the re-establishment of the Florentine Republic.

Michelangelo never returned to Florence, and his pupils finally placed the statues on the tombs in 1545.

## Villa Rotonda (Villa Capra)

*ANDREA PALLADIO, 1550; finished by Vincenzo Scamozzi. Vicenza.*

The Medici inspired generations of wealthy Italians to build country
villas where their families could retreat from the crowded city during
the summer. These "palaces" were built for entertaining guests,
and provided a pleasure residence for the extended family and friends.

### The Courtyard of the Palazzo Vecchio, Florence

A bubbling fountain set within highly decorated columns

graces the interior courtyard of the Palazzo Vecchio in Florence,

a public structure erected between 1298–1340 from the designs of

Arnolfo di Cambio. The building was later restructured by Vasari after

Cosimo I de'Medici came into power and wished to use the palace as a family residence.

# Index